PAINT
LAB *for kids*

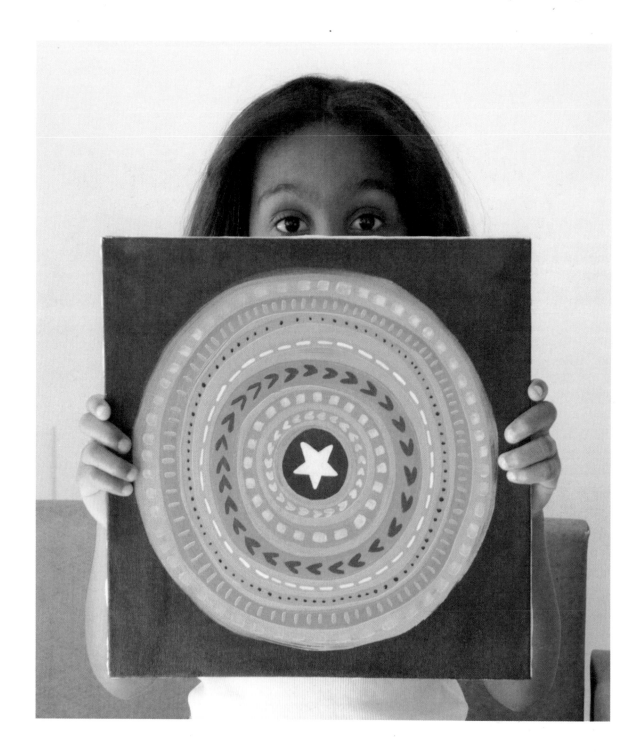

PAINT LAB for kids

52 CREATIVE ADVENTURES IN PAINTING AND MIXED-MEDIA FOR BUDDING ARTISTS OF ALL AGES

STEPHANIE CORFEE

QUARRY

First published in the United States of America in 2015 by
Quarry Books, an imprint of
Quarto Publishing Group USA Inc.
100 Cummings Center
Suite 406-L
Beverly, Massachusetts 01915-6101
Telephone: (978) 282-9590
Fax: (978) 283-2742
www.QuartoKnows.com
Visit our blogs at QuartoKnows.com

10 9 8 7 6 5 4 3 2

ISBN: 978-1-63159-078-8

Digital edition published in 2016

eISBN: 978-1-62788-798-4

Library of Congress Cataloging-in-Publication Data available

Design: Leigh Ring // www.ringartdesign.com
All photography by Stephanie Corfee; with the exception of model shots
by Patrick F. Smith; other photos © individual artists

Printed in China

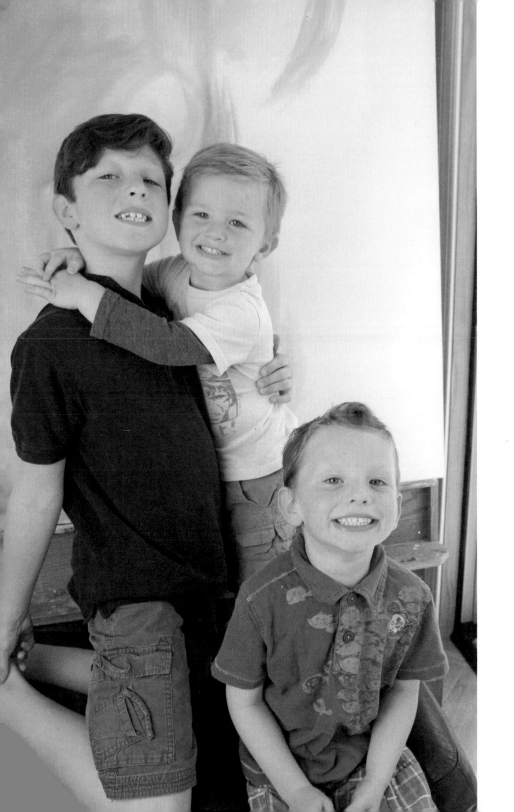

This book is dedicated to
Coop, Grey, and Lang—
my favorite collaborators.

CONTENTS

Introduction **09**

CREATING WITH KIDS **11**
How This Book is Structured **12**

Basic Supplies **14**

Basic Tips to Get You Started **16**

Cleanup and Caring For Your Tools **18**

LEARNING HOW: TECHNIQUE-BASED LABS **21**
Lab 1: Watercolor Blending **22**

Lab 2: Acrylic Blending **24**

Lab 3: Stamped Patterns that Pop **26**

Lab 4: Watercolor Fireworks **28**

Lab 5: Peek-a-Boo Painting: Colorful Cityscape **30**

Lab 6: Drip-Drop Water Techniques **32**

Lab 7: Disappearing Paint: Subtractive Techniques **34**

Lab 8: Copy That: Folded-Paper Insect Monoprints **36**

Lab 9: One of a Kind: Subtractive Monoprints **38**

Lab 10: Draw-to-Paint: Water-Soluble Drawing Tools **40**

Lab 11: Clean & Bright Acrylics **42**

Lab 12: Can't Resist Tie-Dye **44**

WILD IMAGINATION: IDEA-BASED LABS **47**
Lab 13: Watercolor Blob Characters **48**

Lab 14: Acrylic Skins Collage **50**

Lab 15: Mystical Potion Painting **52**

Lab 16: Quirky Pet Portrait **54**

Lab 17: Painting on Water: Marbled Paper Galaxy Painting **56**

Lab 18: Doodle on a Painting **58**

Lab 19: Brushstroke Blooms **60**

Lab 20: Bubbly Print Balloons **62**

Lab 21: If I Had Wings: Decorative Painting **64**

Lab 22: Whole World in Your Hand: Painting in Miniature **66**

PALETTE PLAY: COLOR-BASED LABS **69**
Lab 23: Energy Burst: High-Contrast Minimalist Painting **70**

Lab 24: Ombré Ocean **72**

Lab 25: Pencil Eraser Pointillism **74**

Lab 26: Partner Paint-by-Number **76**

Lab 27: Abstract Mini–Collection **78**

Lab 28: Kaleidoscope Colors **80**

Lab 29: Collaborative Painting **82**

Lab 30: Nine Purple Circles: Dynamic Monochromatic Painting **84**

Lab 31: White Bright: Using White to Expand Your Palette **86**

Lab 32: Photo Inspiration Color Study **88**

UNIT 05

EXPERIMENTATION STATION: MIXED-MEDIA LABS 91

Lab 33: Glue "Batik" Fabric Painting 92

Lab 34: Daydream Painting: Working with Soft Pastels 94

Lab 35: Tissue Transparency Collage 96

Lab 36: Kitchen Sink Painting: Extreme Mixed Media 98

Lab 37: Wood Plank Zebra: Staining Wood with Paint 100

Lab 38: Coffee-Saurus: Sepia Tonal Painting with Coffee 102

Lab 39: Altered Photos: Love You Bunches Painting 104

Lab 40: Dimensional Outlines: Stained Glass Watercolor 106

Lab 41: Lightning Storm: Decoupage & Rubbing Technique 108

Lab 42: On a Roll: Continuous Surface Pattern 110

Lab 43: Paper Towel Transfer Method: Moths 'Round the Moon 112

UNIT 06

EXPRESS YOURSELF: INSPIRATIONAL LABS 115

Lab 44: That's So You! Stylized Self-Portraits 116

Lab 45: Finger-Painting Power 118

Lab 46: Go with the Flow: 15-Minute Intuitive Painting 120

Lab 47: That's My Jam: Painting a Song 122

Lab 48: Art Journaling 124

Lab 49: Hand-Lettered Wood Signs: Decorative Reverse Painting 126

Lab 50: Autograph Painting 128

Lab 51: Go Big: Painting Large Surfaces 130

Lab 52: What a Drag: Scraped-Color Painting 132

Resources 135

Contributing Artists 136

Acknowledgments 137

About the Author 139

Index 141

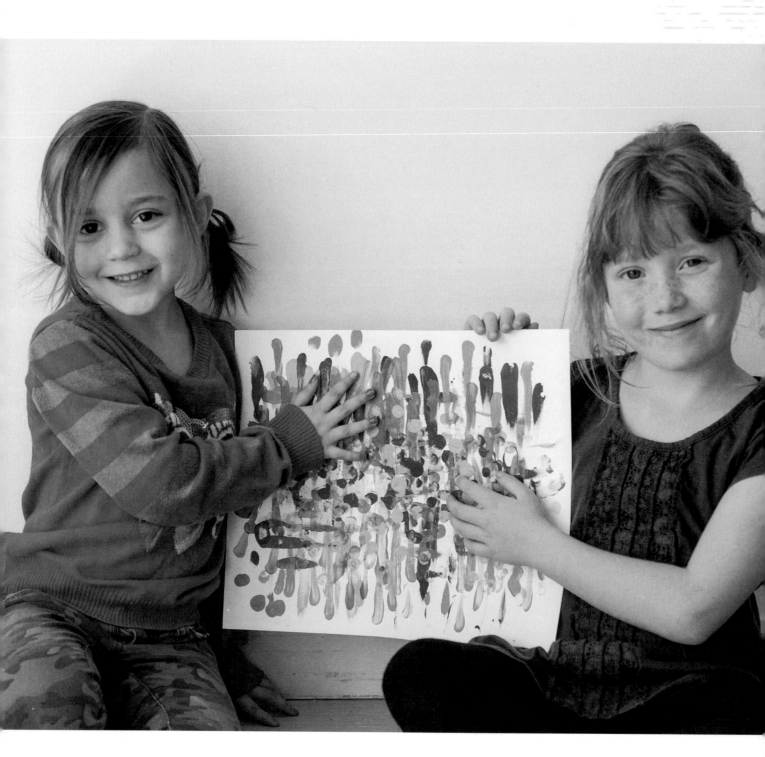

INTRODUCTION

THIS BOOK IS EVERYTHING I COULD EVER HOPE TO SHARE WITH KIDS WHO ARE DEVELOPING A LOVE OF MAKING ART. It is full of color, encouragement, a bit of silliness, some cool techniques, and ideas to *do more* and to *include everyone*. If a project is a bit challenging, I've suggested an adaptation for smaller kids. I truly believe that if art time is family time, and if all kids are empowered no matter their age or skill set, then making art will become a beloved practice that excites kids and helps them develop confidence in themselves.

I know that the confidence I have today had its beginning in my ability to be creative and express myself. When I see that spark in a child, I recognize it, and I want to help it grow. The nicest thing a parent has ever told me is that my lessons were making a visible difference in her child's confidence in her own creativity. That's what it's all about.

These Labs offer engaging projects for both boys and girls with an exciting subject matter. And I couldn't be happier to share all the amazing contributing artists included in each lesson. These artists are so inspiring. I hope that kids will see just how many creative people are out there doing something completely unique and that this will encourage them to want to put their own stamp on the world as well.

The best thing any person, young or old, can do for their creativity is to make something every day. It is a practice. Turn to "Art Journaling Lab," on page 122, and begin that one today, right now. I always tell my son that I exercise my art muscle every day because it's the only way to get better and really get in touch with my creativity. Doodles count! Painting counts! Sketching counts! Start today and see how far it takes you in six months, in a year. You'll be so happy you started today!

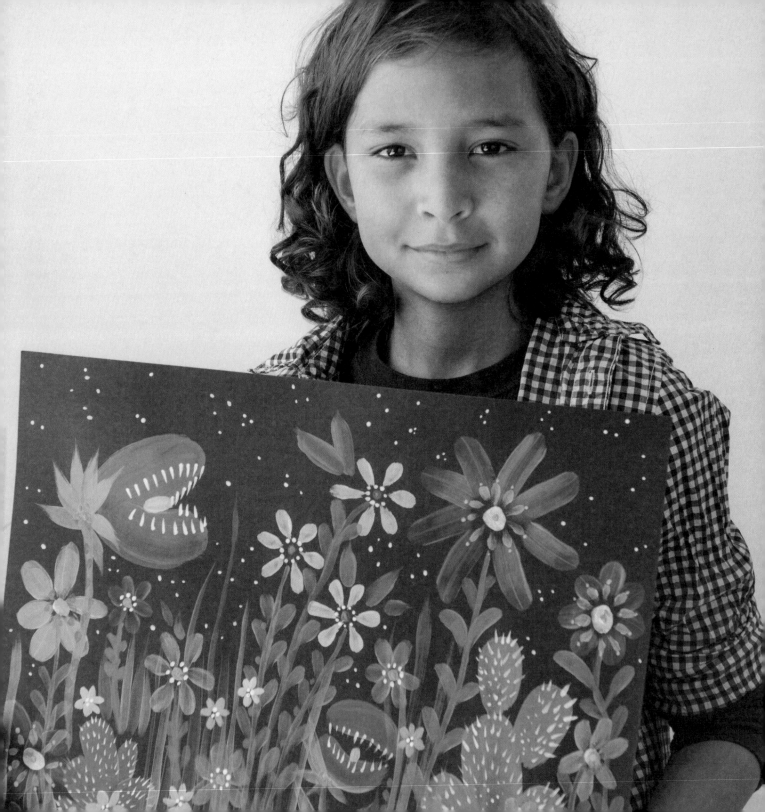

UNIT 01

CREATING WITH KIDS

CREATING WITH KIDS DOESN'T REQUIRE A LOT OF FANCY SUPPLIES, A FORMAL WORKSPACE, OR HOURS ON END. Have lots of supplies on hand, a mix of high-quality materials and discount supplies bought in bulk. Tack fun images and photos to a corkboard and switch them out on a regular basis to inspire imagination. Accept that painting often results in a mess and learn to be okay with that. You and your kids will be happier and more creative as a result.

In this unit is some of my best advice: a list of "Basic Supplies," a description of "How This Book Is Structured," a list of "Basic Tips to Get You Started," and a word about instilling in your children the good habit of "Cleanup and Caring for Your Tools," and an explanation of the color wheel.

NOW, LET'S GET STARTED!

HOW THIS BOOK IS STRUCTURED

THIS BOOK IS ALL ABOUT PAINTING. Every project centers on brushes and paint, so they all have that in common. But you will see that the Units are divided into Learning Labs for learning about supplies and techniques, Wild Imagination Labs for tapping into your child's creativity and imaginative thinking, Palette Play Labs for learning how to work with color, Experimentation Labs for exploring mixed and unusual media, and Express Yourself Labs for guiding the creation of personalized art projects. There is no need to complete the Labs in order. But if your child is a very new painter, the Learning Labs are a great place to get comfortable.

Each Lab presents step-by-step instruction, but I encourage you to break from the steps and let your child do his or her own thing. The steps are meant as a guide, not as strict rules. Your child is the artist. Let them create as they like.

Each Lab also highlights an artist who is making art that is relevant to the lesson in one way or another. I worked so hard to find wonderful contributors who truly inspire. So check out the examples and challenge your child to learn more about these talented individuals. Supporting fellow artists is part of being in the creative community, and it will expand your ideas about art in the world.

Whenever necessary, the Labs have suggestions for adaptations that will make the lesson usable for very young artists. Incorporate these tips, and children of different ages can all do the same project simultaneously. It's a wonderful bonding exercise and so much easier for the parent or teacher.

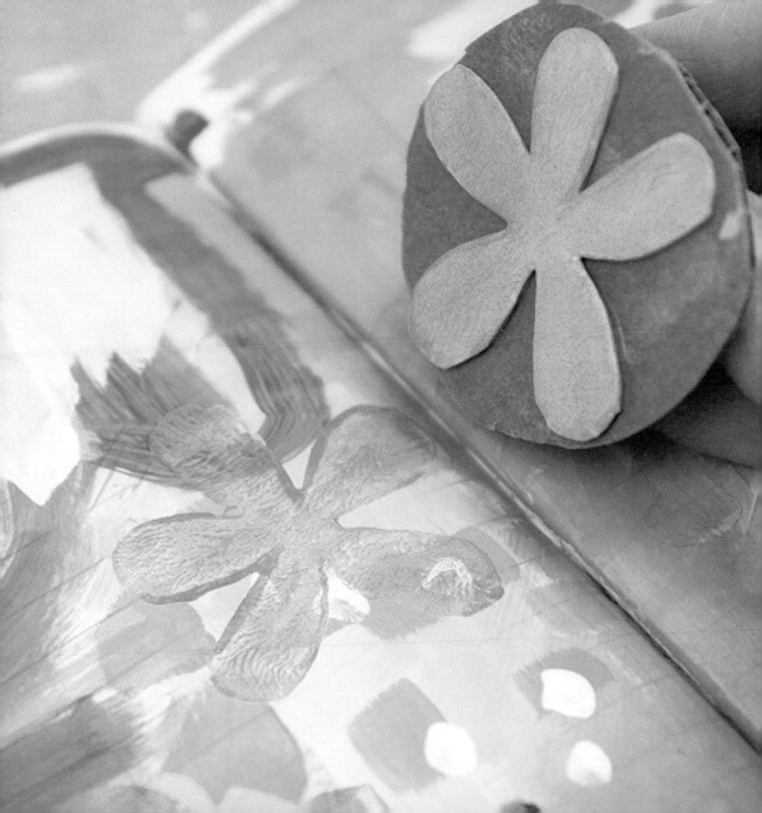

BASIC SUPPLIES

ACRYLIC PAINT Buy nontoxic acrylic craft paints. They are economical, safe, and vibrant. Artist-quality acrylics are a wonderful treat or next step, if you like.

PAINTBRUSHES Go for an artist's basic pack. Stiffer, natural bristles are easier for kids to handle successfully with acrylics. Soft brushes are better for watercolor. Skip kid's packs with 30 brushes that fall apart and opt instead for moderately priced or sale-priced artist brushes.

WATER VESSEL Use a plastic quart-size (950 ml) painter's bucket from the hardware store to avoid making many trips to get clean rinsing water. But any glass or ceramic kitchen bowl will do the trick as well. A container with a broad base will be more stable and less apt to be tipped over by kids rinsing brushes.

PAPER TOWELS Keep a roll on the table for blotting brushes, wiping up spills, placing down messy brushes, and general cleanup.

SMOCK An old shirt works just as well as store-bought smock. Old clothes are a good idea too.

DROP CLOTH If you don't have a designated art room, a drop cloth will save you lots of stress about getting paint on furniture and floors. Cleanup is as easy as rolling the cloth inward and storing it in a drawstring trash bag until the next time.

PAINTING SURFACES Keep on hand a stash of flattened cardboard cereal boxes, shipping boxes, newspaper, bulk-pack canvases, paper, and a nice pad of watercolor paper.

PAINT PENS, PENCILS, AND MARKERS Collect writing and drawing supplies over time and store them in a bucket.

PAPER PALETTE This is a must-have. You can purchase one online or in your local craft store. It's a parent's best friend because it makes for quick paint cleanup after any project. Just tear off the top sheet and discard it. A paper plate also works, but it gets soggy and doesn't have as much room for mixing colors.

MASKING TAPE AND PAINTER'S TAPE Tape is useful in making art and tacking it down to the work surface.

GEL MEDIUM/DECOUPAGE MEDIUM/WHITE GLUE Adhesives are used in making collage and for adding texture to a painting.

PINK SOAP This is a good cleaner for brushes that works on oil, acrylic, and watercolor paints (optional).

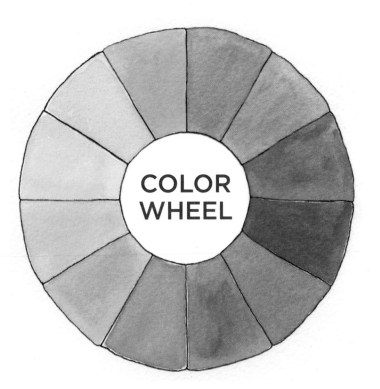

COLOR WHEEL

It's useful to have a color wheel handy when you're working on your art. Choosing colors is a snap when you can refer to the wheel.

PRIMARY colors, red, yellow, and blue, form a triangle on the wheel. Between them are the **SECONDARY** colors, the ones that result from blending the primaries: green, orange, and purple, Colors opposite each other on the color wheel, such as red and green, are called **COMPLEMENTARY** colors. They provide pop and energy when used together in a painting. Neighboring colors on the wheel, such as yellow and yellow-green, are called **ANALOGOUS** colors and create harmony when used together.

Refer to this color wheel, or make your own to keep near your work area.

BASIC TIPS
TO GET YOU STARTED

→ Aim for quality over quantity. This goes for supplies as well as for time.

→ Reconcile your feelings about mess. Without a little mess, there is little fun and spontaneity. Just prepare for the mess: Use smocks. Wear old clothes. Invest in a drop cloth and use it. Life will be so much easier and less stressful when you accept the mess.

→ Use nice paint and brushes. You don't necessarily need artist-level acrylics. Craft paint has great colors and the consistency is excellent for kids. When it goes on sale, stock up. Start out with a set of moderately priced brushes; they will last for ages with proper cleanup. (And cheap brushes that constantly lose their bristles are a drag.) Supplement with brushes available in bulk packs from the hardware store. They hold together nicely, even the bargain-priced ones.

→ Save cardboard for painting and use economy paper often, especially for experimenting. Canvases can be purchased in bulk at the craft store, but they aren't necessary all the time. Always use some type of watercolor paper for watercolor painting. It makes all the difference.

→ Work near a sink or hose. A handy water supply is a wonderful thing.

→ A little goes a long way. Conserve your supplies by starting with small amounts of paint and adjust as you see how much you actually use.

→ Don't assume you need an entire afternoon for every art session. Often, kids will finish in about a half hour or so. There is always a way to squeeze a little creativity into a short time. If you use a drop cloth, cleanup is a snap too. So don't let fear of time commitment scare you off.

CLEANUP AND CARING
FOR YOUR TOOLS

→ It is so important to instill in children the good habit of cleaning up after they work and taking good care of their tools and supplies. Here is a good checklist for your child to run through after each art session.

→ Rinse all brushes well until the water runs clear. Use pink soap, if necessary, and re-form the bristles before laying the brushes on a towel to dry.

→ Store dry brushes with bristles pointing up.

→ Rinse the water container thoroughly so no paint film or residue remains behind.

→ Tear off the used paper palette sheet, fold it in on itself to keep the mess contained, and place it in a trash bin.

→ Wipe down any paint spills immediately, while they're still wet, to avoid stains.

→ Wash hands thoroughly.

→ Hang the smock to dry.

→ Be sure all paint caps are tightly closed to keep paint fresh and to prevent the from drying out.

→ For watercolor, allow wet pan sets to dry before closing the lid. If there are excessive puddles, soak up a bit of the water by dipping a paper towel into the pan.

→ Store finished art flat. Canvases can stand on end.

UNIT 02

LEARNING HOW:
Technique-Based Labs

CREATIVITY, IMAGINATION, AND AN EYE FOR COLOR ARE ALL WINNING QUALITIES FOR AN ARTIST TO HAVE. But before you can put any of them to use, you have to learn the basics. Know your materials. Learn how they behave and what their limitations may be. Get to know all the tools that can be used in your craft.

In this unit, learn the how-to techniques of watercolor blending on both wet and dry paper. Learn about the application of acrylics, when to blend wet paint into wet, and when to allow time for drying. Make your own stamps for creating pattern. And learn how to use household items to add textures and create amazing effects.

Best of all, you will find that all of this knowledge breeds confidence. And with confidence comes the bravery to express yourself. Knowing how to use all the tools in your art box is key. A world of possibilities opens up when you demystify the process of making art. Experimenting is more successful when you know what is likely to work. A little know-how will help you to get the creativity that's in your heart and mind out onto the page.

MATERIALS

→ Watercolor paper

→ Pencil

→ Watercolor paint

→ Paintbrushes

→ Black marker

→ Scrap paper

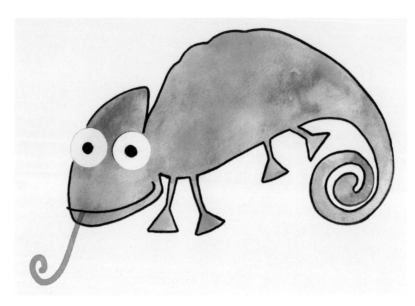

WATERCOLOR IS A WONDERFUL MEDIUM FOR ALL AGES. It is widely accessible, easy to set up and clean up, and comes in many affordable varieties. Kids will marvel at the amazing ways watercolor behaves. In this lesson, practice blending adjacent colors with the wet-into-wet technique. And learn how watercolor flows readily within wet areas of the paper, but stops obediently at the water's edge. Apply these ideas as you create a cute chameleon, the ultimate color-blending creature!

Let's Go!

1. Draw a very simple pencil outline for your chameleon. Use the example here as your guide (fig. 1).

2. Dampen the area inside the penciled shape with clean water. Tint the water with a very small amount of watercolor to help you see the area you've covered (fig. 2).

3. Load the paintbrush with watercolor and touch it down into the wet area. Work left to right, adding new colors one by one and allowing the colors to bloom and blend as they will (fig. 3).

4. Coax the colors along the edges as necessary, but try not to influence the blending. Let the water do the work. It is a fun surprise to walk away and come back when the painting is dry to see how the colors have come together (fig. 4).

5. When the paper is dry, outline the chameleon shape with a bold, black marker. This will make your artwork pop and will also camouflage any choppy edges or "leaks" in the painted shape (fig. 5).

6. Cut two large circles from white scrap paper or extra watercolor paper and add dots for eyes. Glue them to the paper and add a black line for the chameleon's sly smile. A long spiral tongue is the perfect finishing touch to your blended watercolor masterpiece (fig. 6).

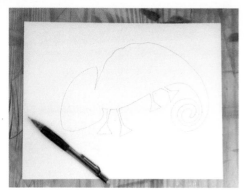
Fig. 1: *Lightly sketch a cute chameleon.*

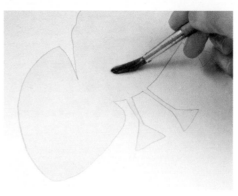
Fig. 2: *Wet the paper inside the outline very carefully with a paintbrush.*

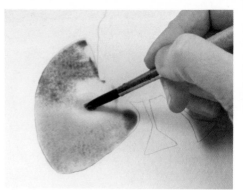
Fig. 3: *Add small areas of color side by side to fill the chameleon shape.*

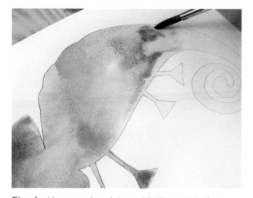
Fig. 4: *Use your brush to guide the paint along the edges; but otherwise, leave it alone. Let dry.*

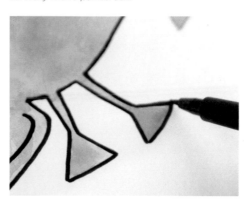
Fig. 5: *Outline the chameleon in black.*

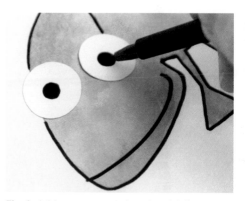
Fig. 6: *Add paper eyes and marker details.*

Inspiring Artist: Anne Bollman

Anne Bollman of *Anne Was Here* created this brilliantly colored example of blended watercolor flowing inside a silhouette. Anne has studied and worked creatively her entire life; she's been an interior designer, a graphic designer, and a stationery designer. Each role uniquely prepared her for her dream career as an illustrator and surface pattern designer. See more of Anne's work at annewashereandthere.com.

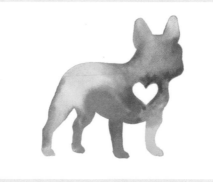
French Bulldog Love by Anne Bollman

Little Hands

Have toddlers drip primary colors (red, yellow, and blue) onto a dampened shape prepared by an adult. Observe as the primary colors blend on the page to create secondary colors while spreading to reveal a familiar shape or form!

ACRYLIC BLENDING

MATERIALS

→ Canvas paper or canvas board

→ Masking tape or blue painter's tape

→ Acrylic paint in red/magenta, yellow, and blue/cerulean

→ Wide, flat paintbrush

→ Paper palette or coated paper plate

Practice, Practice!

—Go beyond primary colors and explore wet-into-wet blending with any colors you like.

—Experiment using more, or less, water in the mix. Do you prefer less water and less blending effect? Or do you prefer more? Become a blending expert and use this new skill in all your paintings.

ACRYLIC PAINT DELIVERS BOLD, OPAQUE COLOR IN AN INSTANT, DRIES QUICKLY, AND WASHES UP EASILY. It is one of the most versatile mediums available. It can be applied in thick layers or watered down so it behaves a bit more like watercolor. In this exercise, make a rainbow-striped name painting using primary paint colors, masking tape, diluted paint, and wet-into-wet blending of the paints right on the canvas.

Let's Go!

1. Use bits of masking tape to spell your name on the canvas. Press the edges down firmly. If you are using canvas paper, tape it down to your work surface (fig. 1).

2. Paint a thin arc of yellow in the center of the canvas paper and fill the remaining top area with magenta and the bottom with blue. Paint right over the tape and work quickly so the paint is still wet for the next step (fig. 2).

3. Widen the yellow band upward into the magenta to create an orange blend. Rinse the brush and widen the yellow band downward into the blue area to create a green blend (fig. 3). You've mixed a rainbow!

4. Once the paper is dry, peel the tape away to reveal your name in the rainbow stripes (fig. 4). Tidy up any paint that may have leaked under the tape with a little white acrylic paint.

Fig. 1: *Mask off your name on the canvas paper (or board) with tape.*

Fig. 2: *Paint magenta, yellow, and blue rainbow stripes on the surface.*

Fig. 3: *Widen the yellow band with more paint to overlap the magenta and the blue. Let dry.*

Fig. 4: *Remove the masking tape.*

Inspiring Artist: Jacqui Crocetta

Soft blending and color transitions are beautifully illustrated in this painting by Jacqui Crocetta. Jacqui is an artist and designer who loves to create large, luminous, abstract paintings and mixed-media sculptures. Her sculptures are made from everyday items that are manipulated and combined in unexpected ways. See more examples of her work at jacquicrocetta.com.

Summer Cadence by Jacqui Crocetta

STAMPED PATTERNS THAT POP

MATERIALS

→ Canvas board or scrap wood painting surface

→ Acrylic paint or craft paint

→ Paintbrushes

→ Paper palette or coated paper plate

→ Corrugated cardboard

→ Craft foam sheets, adhesive backed

→ Craft glue

→ Scissors

→ Brayer (optional)

PATTERN ADDS WONDERFUL LAYERS OF INTEREST, COLOR, AND TEXTURE TO A PAINTING. Using stamps to build pattern is an especially good way for children to try out the technique. Combine contrasting and analogous color schemes to create pop and depth in this highly satisfying exercise. Even beginners can achieve the kind of dynamic results that will keep them engaged, inspired, and stamping the day away!

Let's Go!

1. Use a paintbrush to cover your canvas with swatches and patches of one family of colors (fig. 1). A group of three colors that are side by side on the color wheel works well. This creates more interest than one flat color would.

2. As the backgrounds dries, cut fun shapes from the foam sheets and stick them to squares of cardboard to create stamps. Stack and glue on two smaller cardboard squares for a handle (fig. 2).

3. Pick your favorite stamp. Carefully apply paint from a color group opposite your background colors on the color wheel with your paintbrush or a brayer, if using (fig. 3).

4. Stamp out a pattern all over the background painting. Press firmly, but do not wiggle or slide the stamp on the surface (fig. 4).

5. Create a smaller-scale stamp to coordinate with the larger one (fig. 5).

6. Overlay clusters of the smaller-scale stamp design using a color that is analogous to the other two (fig. 6). This color should fall between the background color and the stamp color on the color wheel. You now have a stamped pattern painting that pops!

Fig. 1: *Paint a mottled background texture using one color group.*

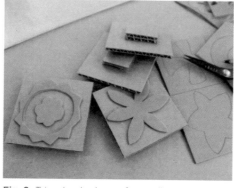

Fig. 2: *Trim simple shapes from adhesive-back foam sheets and make stamps.*

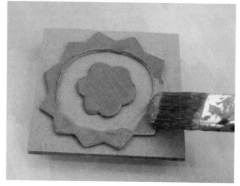

Fig. 3: *Load the chosen stamp with one of the contrasting paints.*

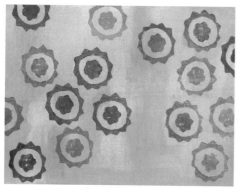

Fig. 4: *Create a pattern.*

Fig. 5: *Make a small accent stamp.*

Fig. 6: *Add sections of the smaller stamp using a third analogous color.*

Inspiring Artist: Jessica Swift

Stamped patterns add drama in this amazing painting by Jessica Swift. Jessica is a full-time artist and surface pattern designer who is on a quest to inspire everyone on the planet to pursue his or her wild and colorful dreams and never give up. Companies and manufacturers for iPhone cases, fabric, and stationery license her artwork. You can find her creating and blogging online at JessicaSwift.com.

Hope, or Let's Just Be by Jessica Swift

Little Hands

Stamping patterns in an orderly, precise way can be challenging for little ones. Make the process more mistake-proof by letting them stamp circles or flower shapes that have no specific top or bottom. A cut carrot has the perfect grip size for a toddler and is easy to dunk in paint rather than apply with a brush. Notches cut around the edges turn the circle shape into a simple flower.

WATERCOLOR FIREWORKS

MATERIALS

→ Watercolor paper

→ Watercolor paint

→ Paintbrushes

→ Drinking straws

→ Rubbing alcohol, 90 percent

→ Toothbrush

Practice, Practice!

—Try layering the blooms so that you get a soft, blended circle with bold color in the center and then create flowers instead of fireworks.

—Use the various techniques in random order for different results or add many layers of each technique for a bolder, more vivid final piece.

DROPLETS, FLECKS, SPATTERS, AND BLOOMS ARE ALL EXCITING EFFECTS YOU CAN GET WHEN YOU PLAY WITH WATERCOLOR. Add a few drops of rubbing alcohol and some drinking straws to the mix and you can create some magical results. Combine all of these techniques at once to create an explosive fireworks painting that will mesmerize at each step in the process.

Let's Go!

1. On wet paper, paint three circles: large, medium, and small (fig. 1). Choose a different color for each. Watch as the watercolors spread and fade outward, or bloom. These soft circles will be the glow of each firework.

2. Add a concentrated puddle of color to the middle of each circle and then blow streaks of color outward in each direction with a straw held almost parallel to the paper (fig. 2).

3. Use a stiff bristle paintbrush or toothbrush loaded with a new color to fleck sparks around each firework (fig. 3).

4. Finish by loading a soft brush with alcohol and then tapping it against your hand to create a spray of droplets at the center of each firework (fig. 4). The alcohol will repel the wet paint and create light areas. The paint must still be wet for this step, so be sure to work quickly.

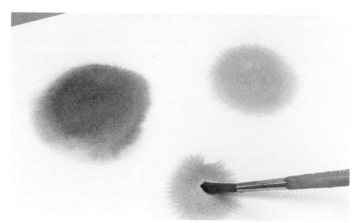

Fig. 1: *Dampen the watercolor paper with clean water. Paint three circles, each a different size and a different color.*

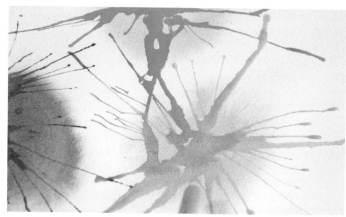

Fig. 2: *Create bold sparks and streaks with a splash of paint and a drinking straw.*

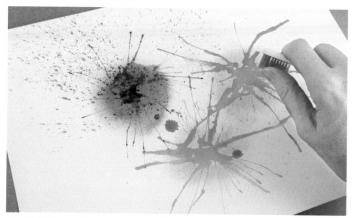

Fig. 3: *Add sparkle to each firework by flicking paint with a stiff brush.*

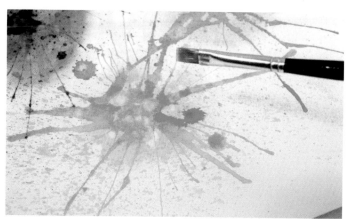

Fig. 4: *Add brightness to the center of each firework by adding droplets of rubbing alcohol.*

Inspiring Artist: Jane Wilcoxson

This brilliant piece by Jane Wilcoxson is a great example of dynamic, explosive watercolor techniques. Jane creates contemporary fine art of quirky animals and fantastical scenes that uses color and playfulness to deliver the magic of the universe to everyday spaces. You can view Jane's work at her gallery in Mineral Point Wisconsin or online at JaneWilcoxson.com.

Splash Seahorse by Jane Wilcoxson

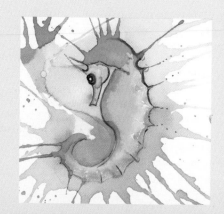

PEEK-A-BOO PAINTING:
Colorful Cityscape

MATERIALS

→ Heavyweight paper or canvas

→ Craft paint or acrylic paint

→ Paintbrushes

→ Paper palette or coated paper plate

Little Hands

For little ones, this exercise works well when the adult and child take turns. Little ones can make a wild background painting, perhaps using their fingers and other fun painting tools such as sponges, rollers, and foam brushes. An adult can mask out the shapes; kids can help by choosing favorite bits of the painting to leave visible. Consider using a sheet of stickers or themed stamps to place inside each window. Finish with lots of white dot stars that kids can make with a cotton swab dipped in white paint.

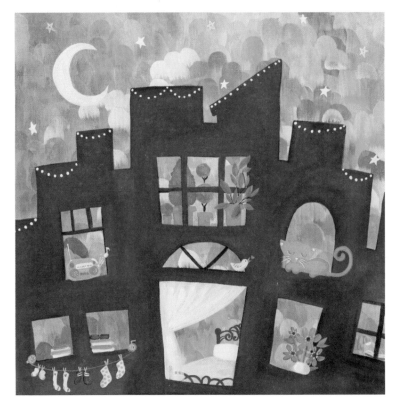

PAINTING SHOULD BE FUN AND FEARLESS. Never be scared to paint over something and start again. In this exercise, have a blast making a bold background with wild texture and vibrant color. Then layer paint over much of your work to create "peekaboo" windows that highlight the best sections of the work. Make a cityscape painting that shows the glowing windows in a building at night. Add some fun details that you might see in the windows like pets, people, flowers, or kids wishing on a shooting star.

Let's Go!

1. Paint over the entire paper or canvas with a paintbrush using vibrant colors (fig. 1).

2. Once the background is dry, paint the skyline shape of buildings and then add some quirky windows (fig. 2).

3. Fill in the building shape with darker color (fig. 3). You can alternate using black, navy, purple, and magenta. Blend as you go, but there's no need to be very careful. Visible brushstrokes and color variation make the painting more interesting.

4. Add personality to your painting by imagining what you might see if you peeked in each window and painting those items (fig. 4). Make your painting fun to look at and have it tell a story. Sign your finished painting; you are a fearless painter and storyteller.

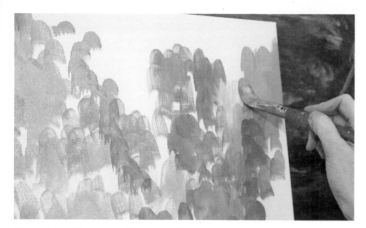

Fig. 1: *Cover the paper with paint with energetic strokes in fun colors. Let dry.*

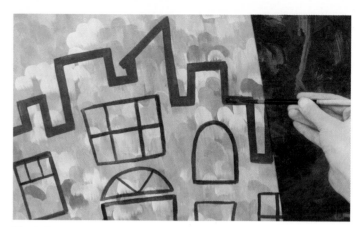

Fig. 2: *Paint the outline of a few buildings with windows.*

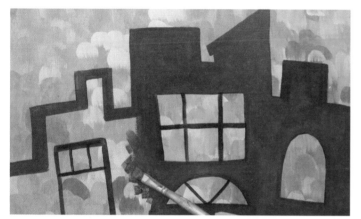

Fig. 3: *Fill in the spaces around the window outlines with slightly darker paint colors.*

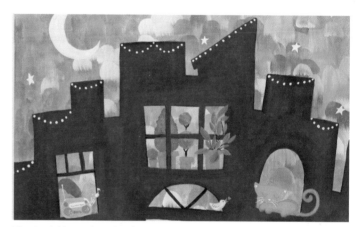

Fig. 4: *Add people, animals, or objects in each window.*

Inspiring Artist: Maria Carluccio

Look at Maria Carluccio's gorgeous example of texture masking; each little "window" reveals underground creatures. Maria is an accomplished textile and product designer as well as a children's book author and illustrator. She has received multiple awards for her work from the Society of Illustrators in New York and *3x3, The Magazine of Contemporary Illustration*. Maria draws much of her inspiration from her surroundings in nature. See more of her work at mariacarluccio.com.

Underground Exploration by Maria Carluccio

DRIP-DROP WATER TECHNIQUES

MATERIALS

→ Stretched canvas or canvas board

→ Craft paint or acrylics in several colors including titanium (opaque) white

→ Paintbrushes

→ Paper palette or coated paper plate

→ Water

→ Squirt bottle

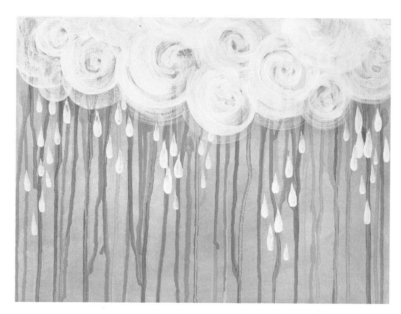

WATER PLAY IS ALWAYS A BIG HIT WITH KIDS. Add some colorful paint to the mix, and you've got a guaranteed winner. In this exercise, paint a whimsical raincloud and a colorful rainstorm. Kids learn to create and control different paint consistencies and use a squirt bottle for drippy, watery effects on canvas—and they end up with the world's most cheerful, drippy rainstorm!

Let's Go!

1. Paint the entire canvas using a light blue-gray, like the color of a rainy day, and let it dry completely (fig. 1).

2. Mix a few bright paint colors with water to get a drippy consistency similar to melted ice cream. Load a paintbrush with lots of the thinned paint and drag a juicy band of color horizontally across the top of the painting (fig. 2).

3. Spritz water at a downward angle to encourage the drips to run down the painting (fig. 3).

4. Load a different thinned color onto the brush and press it against the canvas to squeeze the paint out of the bristles and down the canvas. Reload and repeat in several different areas (fig. 4).

5. Repeat both types of drip techniques in layers using different colors until you like the result (fig. 5).

6. When the drips have dried, use titanium white paint to add a swirly cloud at the top of your painting and finish with some white droplet shapes (fig. 6).

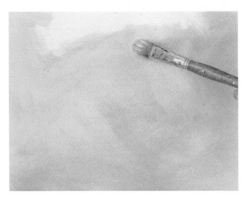

Fig. 1: *Coat the canvas with blue-gray paint. Let dry.*

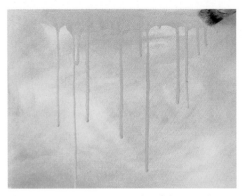

Fig. 2: *Apply a generous stroke of drippy paint at the top of the canvas.*

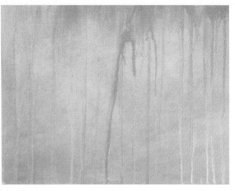

Fig. 3: *Spray the painted area with water to force more drips downward.*

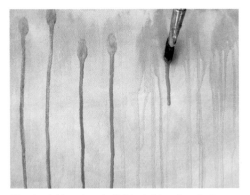

Fig. 4: *Add various individual drips directly from the paint-loaded brush by pressing down.*

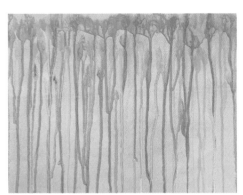

Fig. 5: *Continue layering drip clusters and singles. Let dry.*

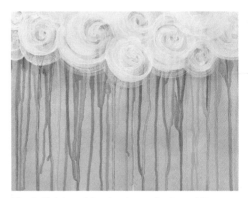

Fig. 6: *Paint a white cloud over the top of the drips.*

Inspiring Artist: Lesley Grainger

Lesley Grainger shows a masterful use of paint drips in this painting. Lesley draws inspiration from her faith, her family, and nature. She works intuitively, exploring color, movement, and texture. She has partnered with high profile companies such as Oopsy Daisy, Papyrus, Raz, Riley Blake, Target, and Walmart and her children's books are available in many stores worldwide including, recently, Harrods of London. Learn more at lesleygrainger.com.

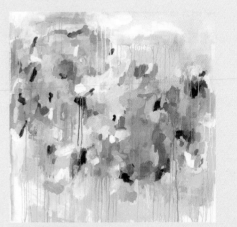

Flying Faith by Leslie Grainger

Practice, Practice!

—Try tilting and turning your canvas as you add drips to change the direction of their path.

—Let layers of drips dry and then turn the canvas on its side and drip again to create a crisscross pattern.

DISAPPEARING PAINT:
Subtractive Techniques

MATERIALS

→ Coated poster board
 (One side is shiny.)

→ Scissors

→ Painter's tape

→ Tempera or craft paint

→ Paintbrushes

→ Paper palette or coated
 paper plate

→ Plastic wrap

→ Paper towels

→ Cotton swabs

→ Glue stick or white craft glue

Little Hands

It is important to work quickly in this exercise so the paint doesn't dry before the technique can be applied. Make it easier for small children by working on a much smaller scale, using large brushes. They will enjoy the added bonus of being able to create several small artworks from a single sheet of poster board. A 5" x 7" (12.7 x 17.8 cm) size works perfectly.

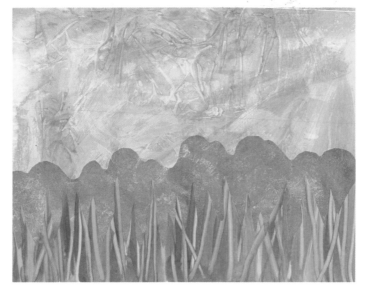

ADDITIVE PAINTING TECHNIQUES ADD COLOR TO A SURFACE. SUBTRACTIVE PAINTING TECHNIQUES PULL PAINT AWAY. Both can be equally useful in creating interest and texture in an artwork. In this exercise, apply three simple subtractive methods to create a layered and colorful abstract landscape painting complete with sky, shrubs, and trees.

Let's Go!

1. Have an adult cut the poster board in half. Then cut one half into one large and one small strip (fig. 1)

2. Tape the large piece of poster board to your work surface. Work quickly with a large brush to cover the shiny side of the of poster board in shades of blue (fig. 2). The coating will keep the paint from absorbing into the paper too quickly.

3. Apply a large sheet of plastic wrap over the blue paint, making lots of creases and wrinkles in the plastic wrap as you press it down with your fingers (fig. 3). Then remove the plastic wrap and see the pattern that is left behind after some of the paint is lifted off (fig. 4).

4. Tape the medium piece of poster board to your work surface. Cover the shiny side of the poster board with red and orange paint. Crinkle a paper towel and blot away paint so you have clusters of texture that represent trees and shrubs (fig. 5). Use a clean towel when the one you are using becomes too full of paint.

5. Tape the small piece of poster board to your work surface. Paint the shiny side of the poster board strip with yellows and bright greens (fig. 6). Use cotton swabs to draw into the paint with vertical and diagonal lines to represent tall grass.

6. Cut the red strip with a bumpy, scalloped edge to resemble the top of shrubs and trees. Cut the green strip with spikey zigzags to look like grass. Arrange in layers and glue to the background (fig. 7).

Fig. 1: *Trim the poster board to three sizes: small, medium, and large.*

Fig. 2: *Tape the large poster board to your work surface. Then coat the shiny side with blue paint.*

Fig. 3: *Cover the blue paint with wrinkled plastic wrap.*

Fig. 4: *Peel away the plastic wrap.*

Fig. 5: *Tape the medium poster board to your work surface and paint the shiny side red and orange. Dab with a crumpled paper towel.*

Fig. 6: *Tape the smallest strip of poster board to your the work surface and paint the shiny side yellow and green. Scrape lines from the surface with cotton swabs.*

Inspiring Artist: Barbara Chotiner

This beautiful piece by Barbara Chotiner perfectly illustrates the use of painted and textured papers. Barbara is an accomplished artist, designer, and coffee lover, who lives and works on her creations in a suburb just outside Philadelphia. Barb creates colorful, whimsical, and sophisticated designs for numerous clients and is a fan of combining traditional techniques with modern approaches. See more of her work at bzdesignstuff.com.

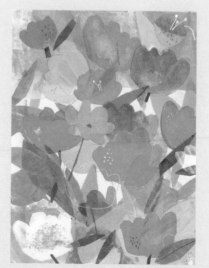

ReadySetGrow by Barbara Chotiner

Fig. 7: *Trim the pieces and layer them.*

COPY THAT:
Folded-Paper Insect Monoprints

MONOPRINTING IS A WAY TO TRANSFER AN IMAGE FROM A PLATE (A SURFACE ON WHICH A DESIGN HAS BEEN APPLIED IN PAINT OR INK) TO PAPER.

MATERIALS

→ Heavyweight paper (suitable for painting)

→ Tempera or craft paint in various colors

→ Paintbrushes

→ Paper palette or coated paper plate

→ Images of insects (to inspire creativity)

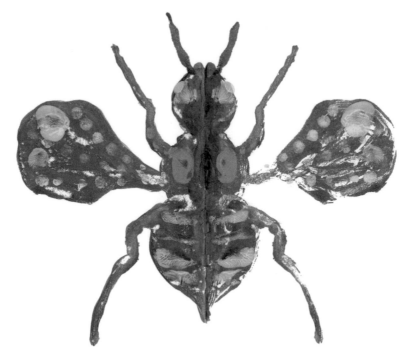

It's called a *monoprint* because it's one of a kind—it will never be duplicated identically again. Use this simple, folded-paper monoprint technique to create a mirror-image art print of an insect.

Let's Go!

1. Fold a piece of paper vertically, and then reopen and flatten it on your work table (fig. 1).

2. Working quickly so the paint doesn't dry, paint half of an insect to the left of the fold. Look at a photo to help you paint the left side of your chosen insect. Be generous with the paint so there's enough to make a print (fig. 2).

3. Fold the blank half of the paper over the painted side and press down to get an impression (fig. 3). Pat gently to avoid smearing the design.

4. Peel back the left side to reveal the completed monoprint (fig. 4). Touch up any gaps in the print with your brush.

5. Repeat the paint-on-left, print-on-right sequence several times using different colors to add wings, markings, and other details (fig. 5). The result is a perfectly symmetrical, one-of-a-kind insect monoprint! Bet you can't make just one!

Fig. 1: *Create a center fold in the paper to use as your guide.*

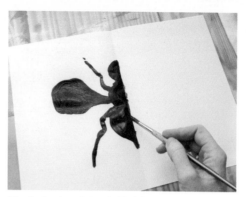

Fig. 2: *Apply paint to half of the paper.*

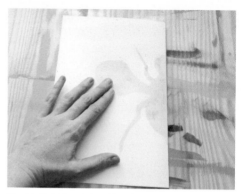

Fig. 3: *Fold the right side of the paper onto the left.*

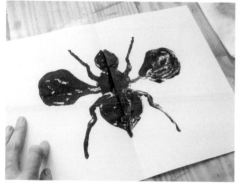

Fig. 4: *Open the paper to check your work. Touch up as needed.*

Fig. 5: *Repeat to add layers of detail in different colors.*

Inspiring Artist: Amy Adams

Artist Amy Adams creates amazing, symmetrical images using ink, folded paper, and a technique similar to the one shown in this lesson. Her abstract inkblots inspire endless creativity. She invites viewers, including her own kids, to see and imagine anything they like in them. See more of Amy's artwork at .etsy. com/shop/RubyMoonDesigns.

Ink-sect by Amy Adams

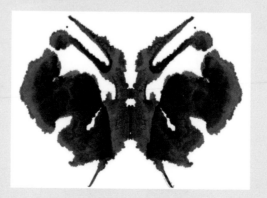

Little Hands

This project is great fun for small kids. Some won't care if their bug looks like a bug at all. But if you have a perfectionist toddler (like I do), I recommend that you paint the basic shape of the insect for them and then allow them to add the details. Adding the details goes quickly, and the paints won't dry out before you have the chance to make the print. Plus, little ones adore the magical opening and closing of the paper best anyway!

ONE OF A KIND:
Subtractive Monoprints

→ Paper palette or coated paper plate

→ Paintbrushes

→ Tempera paint

→ Cotton swabs

→ Heavyweight paper

Little Hands

Little ones can make the most precious subtractive monoprint of all by pulling away their handprint from the plate. Have them load paint on and then help the child press their hand and pull it away to reveal the print. An adult can use a cotton swab to add the name and date. Note: When using this method, make sure the paint is safe for contact with the skin and wash children's hands immediately afterward.

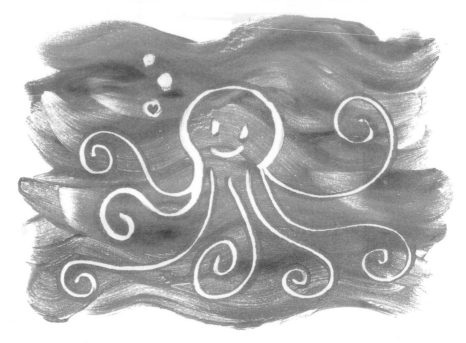

IN THE LAST LESSON, YOU MADE A MONOPRINT BY *ADDING* PAINT TO YOUR "PLATE" BEFORE PRINTING. In subtractive monoprinting, you make a design by *removing* paint from a loaded plate before printing to paper. In this exercise, use simple supplies to make a one-of-a-kind subtractive monoprint of a friendly octopus floating about in the sea.

Let's Go!

1. Apply a generous layer of paint to the paper palette (fig. 1). Don't feel limited to blue; your water can be purple or orange if you like. Drag your brush across the page with wavy strokes to resemble ocean waves.

2. Working quickly so that the paint does not dry, draw an octopus using the cotton swabs (fig. 2). Remove paint with the swabs anywhere you'd like to see white on the final print.

3. Place the paper over the "plate" you have created and press down gently. Then peel it away to reveal your monoprint (fig. 3). Remember, any imperfections are what make it one of a kind and special.

4. Paint one special detail on the print in a contrasting color (fig. 4). This really makes a difference and gives your artwork that extra bit of personality.

Fig. 1: *Coat the paper palette with paint.*

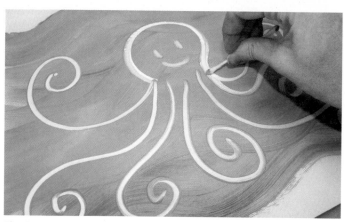

Fig. 2: *Draw an octopus shape using cotton swabs.*

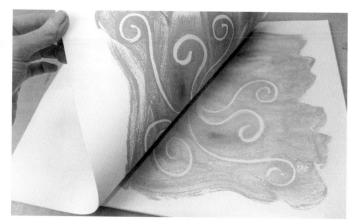

Fig. 3: *Make the print.*

Fig. 4: *Add one detail in a second color.*

Inspiring Artist: Traci Bautista

Subtractive monoprints made with gelatin plates called *gelli plates*, plus various mixed media, come together in this wild and intricate piece by Traci Bautista. Traci is a mixed media artist, designer, teacher, and creative director of treiC Designs. She is the author of three best-selling mixed-media books, *Collage Unleashed*, *Doodles Unleashed*, and *Printmaking Unleashed*. To learn about her artwork, visit treicdesigns.com.

Floral Graffiti by Traci Bautista

DRAW-TO-PAINT:
Water-Soluble Drawing Tools

MATERIALS

→ Watercolor paper

→ Water-soluble crayons or watercolor pencils

→ Paintbrushes

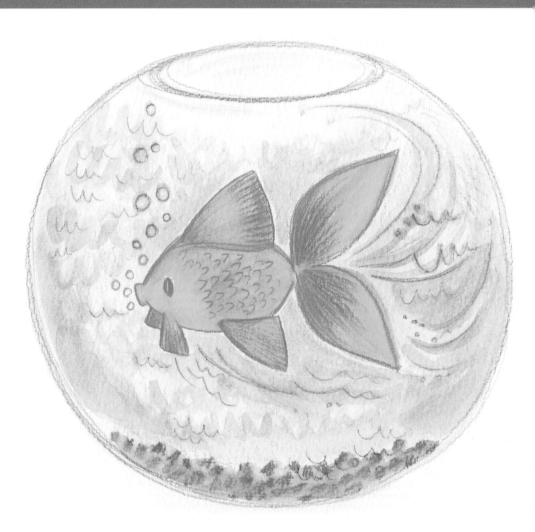

WALK BEFORE YOU CRAWL. DRAW BEFORE YOU PAINT. If paint is a little bit intimidating, some great alternatives are water-soluble drawings tools like watercolor pencils and water-soluble crayons. You draw on the page with these tools just like regular pencils or crayons, but you make magic when you brush water on. The colors dissolve and become spreadable so you can move them around a bit just like paint. Create an adorable fishbowl "painting" in this lesson by drawing first, painting second.

Let's Go!

1. Use your pencils or crayons to make a simple line drawing of a fish in a round fishbowl (fig. 1). Be sure to add some wavy shapes inside the bowl to look like water and some dots at the bottom for gravel. The more color you apply, the more "paint" you will have on the page to work with in the following step.

2. Use clean water and a paintbrush to start moving some of the color around (fig. 2). Blend some of the gravel together. Smooth the color on the fish. Soften the outline of the fishbowl. Spread the waves in the water around to fill more of the bowl shape. For bold color, add any final details with pencils or crayon right on top of the wet paper.

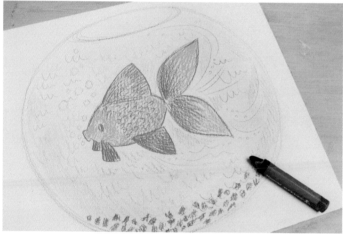

Fig. 1: *Make a drawing with plenty of colored detail.*

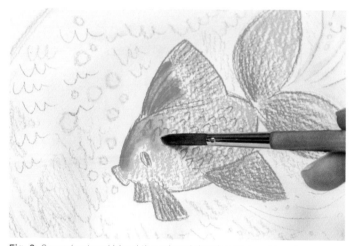

Fig. 2: *Spread out and blend the colored details with a wet brush.*

Inspiring Artist: Alex Leigh Franklin

The color and textures are so beautiful in this watercolor pencil piece by Alex Leigh Franklin, an artist who lives in the Northern California. Alex's focus is on illustration with watercolor and watercolor pencil. "Travel, studying new types of plants, and reading creative literature, like stories by C.S. Lewis, inspire me. I feel as though I am my most complete self whenever I am being creative." Learn more at alexleighfranklin.com

Queen Victoria Pineapple
by Alex Leigh Franklin

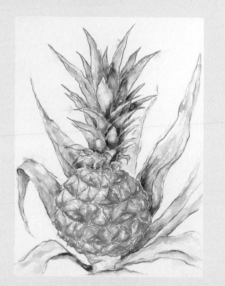

Little Hands

Small children may not be able to create a detailed drawing, but they can still enjoy water-soluble drawing tools as they work on color mixing. An adult can draw several sets of crisscrossed lines of colors that will blend on the page. Try yellow horizontal lines crossed by vertical blue ones. Have little ones brush on the water and see how amazed they are when a green puddle appears. Make it a color-theory guessing game they will master in a flash!

CLEAN & BRIGHT ACRYLICS

MATERIALS

→ Stretched canvas

→ Acrylic paint

→ Paintbrushes

→ Paper palette or coated paper plate

Little Hands

Keeping complementary colors separate is really the best way for small children to succeed in this technique. Let them work with like colors in a warm palette in any way they choose for five minutes. Abstract brushstrokes are just fine. Then have them choose a set of cool colors while you rinse the brushes. This allows time for the first layer to dry. Then they can work for another five minutes. Cheer them on as they apply each bright layer and talk about how the colors are different. There will be no mud in sight.

IT'S EXCITING TO DIVE IN AND WANT TO USE EVERY COLOR IN THE PAINT BOX AT ONCE, BUT ONE OF THE BIGGEST CHALLENGES IN PAINTING IS LEARNING HOW TO AVOID BLENDING THE COLORS SO MUCH YOU END UP MAKING MUD. A bit of patience and some strategy can help you avoid a murky finished artwork. In this exercise, create a crisp, bright bull's-eye painting by working the canvas strategically, moving from one area to the next, so that colors are always layered wet over dry, with no blending. My boys toss foam Ping-Pong balls at their bull's-eye canvas. It's art *and* a game!

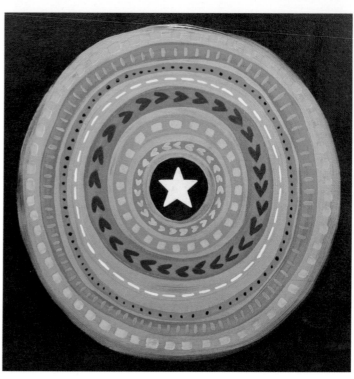

Let's Go!

1. Paint a dark background color like navy (fig. 1). Allow it to dry. Then paint a large circle in a light version of that color, like baby blue. Allow it to dry.

2. Choose one complementary color and paint two rings with space between. Then choose a different color and paint a dashed ring over the outermost edge of the light blue circle (fig. 2). By now, the first ring you painted will be dry and you can go back and decorate it with a contrasting color, then you can work on the second ring, and so on.

3. Continue the pattern of painting contrasting details and bands of color over areas that have already dried (fig. 3). In this way, you create sharp contrast with no inadvertent blending of color. Finish with a star at the center.

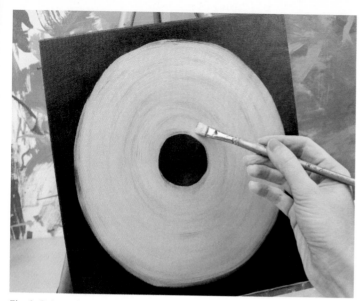

Fig. 1: *Paint a dark background and allow it to dry. Then paint a light circle.*

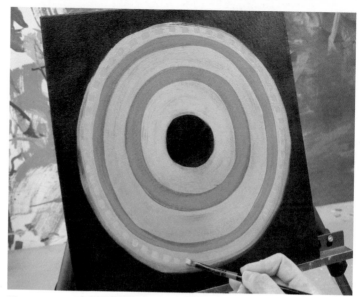

Fig. 2: *Paint contrasting circles and a dashed ring around the edge.*

Inspiring Artist: Valerie Wieners

This eye-popping floral by Valerie Wieners gets its energy from clean, bright layers of acrylic paint. Valerie's style is colorful, whimsical, and inspired by her faith and life journey so far. Valerie has a love of pretty flowers and gorgeous lettering. Both are frequent themes in her art, which can be seen at valeriewienersart.com.

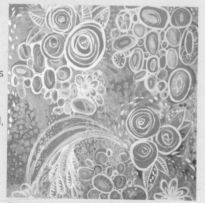

Floral Excitement by Valerie Wieners

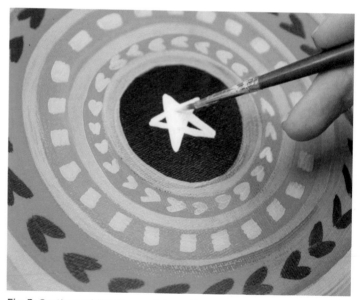

Fig. 3: *Continue adding rings and decorations.*

CAN'T RESIST TIE-DYE

MATERIALS

→ White or very light colored wax crayons

→ Watercolor paper

→ Masking tape

→ Watercolor paint

→ Paintbrushes

→ Spray bottle

Practice, Practice!

—Try making striped or zigzag designs with crayons, or create a repeating pattern of similar drawings across the page.

—Add layers of watercolor washes to get a more sophisticated look, one full of depth and unique color mixes.

—Create a secret message painting to share with a friend. Write a message in white crayon that your friend will discover only by painting over the page.

KIDS WILL LOVE WATCHING THEIR DRAWINGS AND SCRIBBLES APPEAR LIKE TIE-DYE MAGIC IN THIS QUICK LESSON IN WAX RESIST. Use white or light colored wax crayons to create drawings on porous watercolor paper. Then fill the page with vibrantly colored paint and watch as the paint beads and flows away from the wax markings. Use a very light colored crayon rather than white to make it easier for younger kids to see where they are drawing.

Let's Go!

1. Draw a faint pencil spiral on watercolor paper as a guide (fig. 1). Scribble tight zigzags all along the length of the spiral with white crayon (shown in light blue in the photo for better visibility). Press hard as you draw. The more wax on the paper, the better the designs will show up.

2. Add doodles in the space between the spirals with the crayon (fig. 2). Remember to press hard.

3. Tape the paper to the work surface to prevent curling. Spray the paper to dampen it and distribute the water with a brush to cover it completely (fig. 3). Use watercolors all along the spiral, alternating bright colors and painting right over the wax drawings. The watercolor will bead up and move away from your designs. Add more paint as the artwork dries to make the colors bolder and the resist areas will really stand out.

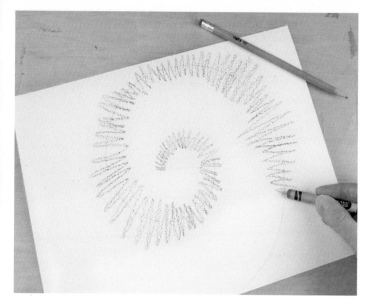

Fig. 1: *With a white crayon, make a zigzag spiral (shown here in blue for visibility).*

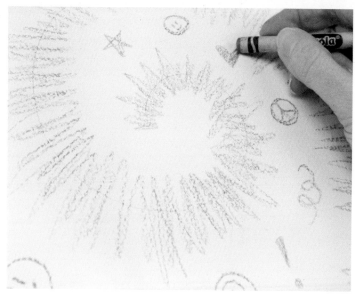

Fig. 2: *Add some fun doodles.*

Inspiring Artist: Catherine Herold

Catherine Herold used masking fluid rather than wax crayon to create these beautiful examples of the watercolor resist technique. Catherine is a graphic designer and painter with a real connection to her customers. "I want to create affordable art pieces that people can use to decorate their own spaces. I like the fusion between the organic, unpredictable nature of paint and the structure of well-planned design." See more of Catherine's work at fire-spark.net.

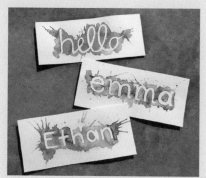

Name Splatter Paintings by Catherine Herold

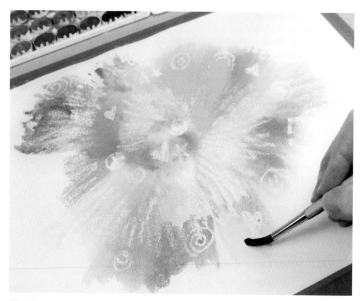

Fig. 3: *Wet the paper and add paint.*

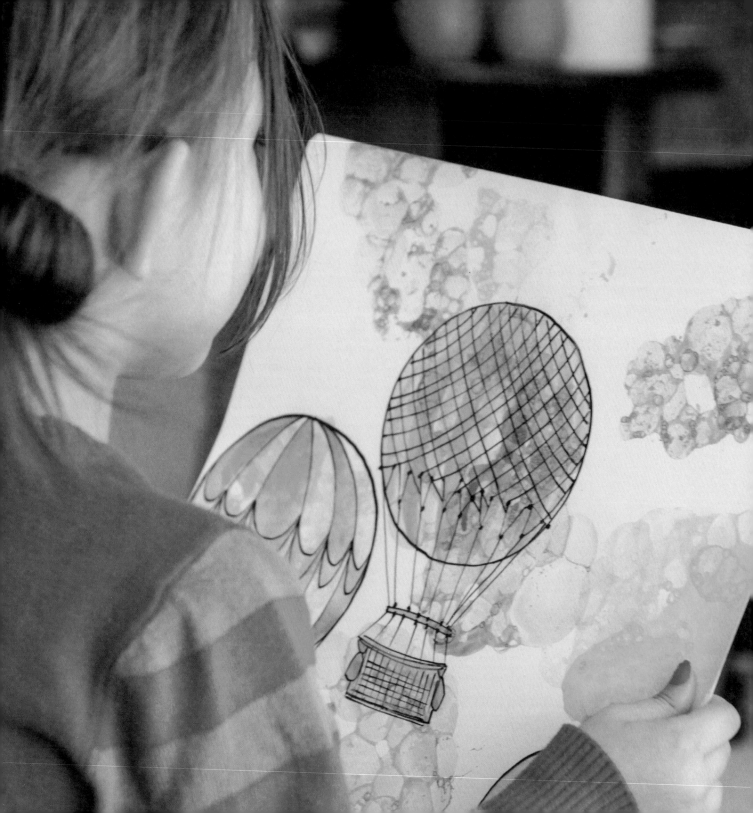

UNIT 03

WILD IMAGINATION:
Idea-Based Labs

IMAGINATION IS ONE OF THE MOST IMPORTANT COMPONENTS IN THE PROCESS OF MAKING ART WITH CHILDREN. It not only provides ideas and inspiration, but imparts the unwavering confidence a child needs to go ahead and paint that cat pink, that sky zigzag, and that fabulous garden of wildflowers growing from the ceiling! Unleashed imagination can mean the difference between a project that is merely executed and one that is inspired and magical. Kids have the most beautiful innate ability to prioritize their wild imaginations and individual perspectives over pinpoint accuracy. It's so important to support this! I often tell my own little boys, "I don't need it to be *perfect*—I only need it to be perfectly *you*." I truly want all kids to hear this: to feel comfortable taking risks and having fun, rather than worrying about the idea of right or wrong. That creative freedom tends to lead to the best results.

This unit challenges kids to see things in new ways, to develop their "artist's eye," and to gain confidence in their uniqueness. Here are the only rules:

→ Use your tools and supplies in inventive ways.

→ Revel in the process more than the result.

→ Paint your world as you feel it more than as you see it.

→ Trust your wild imagination to help you create a one-of-a-kind artistic vision.

→ Have fun!

Now, go make some magic!

WATERCOLOR BLOB CHARACTERS

MATERIALS

→ Watercolor paper

→ Watercolor paint

→ Paintbrushes

→ Pens, pencils, markers, and other tools to add details

WE CAN FIND BEAUTY IN EVERYDAY OBJECTS AND TURN BASIC MATERIALS INTO SOMETHING IMAGINATIVE AND NEW. Not every artwork has to begin with a firm plan in mind. This exercise is all about spontaneity. Create three random watercolor shapes or blobs. They can be blended or single color, dark or light. They can have smooth edges or jagged ones. It's up to you. Study them. Turn each one into a character by adding eyes and noses, arms and legs, and whatever else you envision. Once you get going, you won't be able to stop!

Let's Go!

1. Paint three watercolor shapes (fig. 1). Play with blending, straw blowing, blooms, or flooding to create the forms. Try to make each one different so you can challenge yourself in the next steps. Let dry.

2. Turn one blob into a monster, one into a person, and one into an animal by adding details in ink (fig. 2).

3. With paint, add color and pattern to the drawings to give your characters personality and style (fig. 3). Imagine all the amazing characters you can create this way! Cut them out and use them to make cards, frame them in shadowboxes, or create a huge chart of characters that will be the hit of any play space.

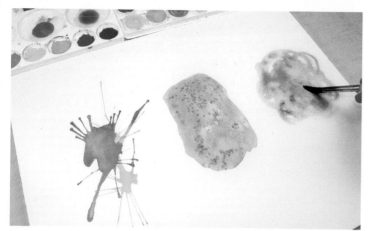

Fig. 1: *Paint three watercolor blobs, allowing each to dry before adding details.*

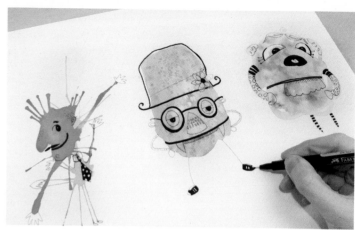

Fig. 2: *Using pens and markers, create characters from each blob.*

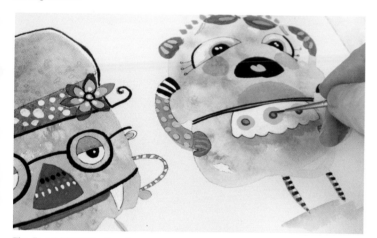

Fig. 3: *Add finishing touches.*

Inspiring Artist: Melissa Ramirez

Melissa Ramirez makes imaginative and spontaneous watercolor characters called "Imaginos." Born in Panama, Melissa now lives in Sunshine Coast, Queensland, Australia. She exhibits her art, takes on commissioned pieces, and periodically works as a scenic artist on photo shoots and television shows such as *Survivor*. Learn more about her work and see the process at nuviart.com.

Antoin by Melissa Ramirez

Little Hands

Very little children may have difficulty controlling a pen and making details, but they have wonderful imaginations. Why not partner with your young ones? Have them make fun, blobby shapes and then tell you a story about what each one is. They will act as your art director, telling you where eyes, hands, and feet should be drawn. When I do this with my three-year-old, there is always as much giggling as there is painting.

ACRYLIC SKINS COLLAGE

MATERIALS

→ Paper palette or coated paper plate

→ Acrylic paint

→ Paintbrushes

→ Kraft or drawing paper

→ Pencil

→ Scissors

→ Matte medium, white glue, or decoupage adhesive

A PAINTER'S PALETTE IS SOMETIMES AS INTERESTING AS THE PAINTING SHE'S WORKING ON. Layers of blended color, mixed and swirled on a paper palette, are just irresistible. Once they are dry, you can peel these flexible sheets of paint from the palette and then incorporate them into a collage by attaching them with gel medium or by using acrylic paint as a binder. In this exercise, create an imaginary creature using acrylic "skins" just like you would use scraps of paper for color, texture, and interest.

Let's Go!

1. Make a painting full of color, brushstrokes, swirls, dots, and blends on a paper palette (fig. 1). You will need to allow a few hours or even overnight for it to dry, depending on how thickly the paint is applied. Large lumps will stay moist in the middle for a couple days so try for a very thick paint application with no large, deep lumps. The paint will shrink and flatten quite a bit as it dries.

2. Once it's dry, peel the paint skin from the palette (fig. 2). Don't worry if it doesn't come off perfectly; you will be tearing and cutting it up for the collage anyway.

3. Use your imagination to sketch a creature on the kraft paper (fig. 3). You can combine features of two separate animals or make up something completely new. Older kids can try for more detail; younger kids can create simple shapes.

4. Paint any areas of your creature that you would like to remain solid (fig. 4).

5. Use acrylic gel medium (or thinned white glue or decoupage adhesive) to attach pieces of the acrylic shreds to the artwork, filling in the desired areas (fig. 5). Use scissors to cut specific shapes or tear pieces for a ragged look.

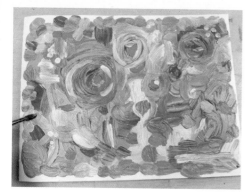

Fig. 1: *Paint thick acrylics onto a paper palette. Allow it to dry.*

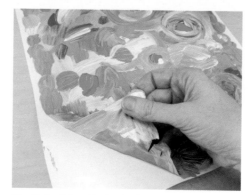

Fig. 2: *Peel the dried paint from the palette.*

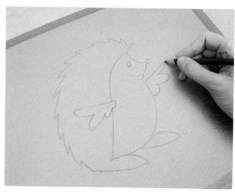

Fig. 3: *Sketch a fun creature on kraft paper.*

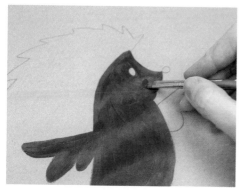

Fig. 4: *Paint the solid areas.*

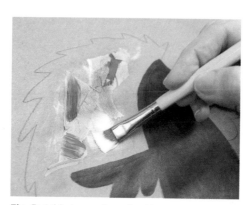

Fig. 5: *Add pieces of acrylic skin.*

Inspiring Artist: Nancy Standlee

Inspired by an art workshop on collage, Nancy Standlee created this acrylic skins painting. Nancy is a native of Texas, attended Texas colleges, and retired as an elementary school librarian more than a decade ago. She is an award-winning contemporary artist and works in a variety of mediums like oil, acrylic, mixed media, and torn-paper collage, producing joyful and cheerful paintings. See more at nancystandlee.com.

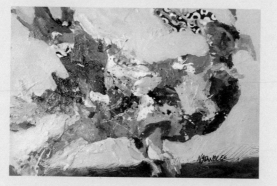

Silly Bird by Nancy Standlee

Little Hands

Instead of painting the skins, little ones can pour puddles of craft acrylic paint directly from a squeeze bottle. When they dry, the resulting dots are easy to peel off. Kids can also use safety scissors to cut shreds from the acrylic skin, using them for spikes, fur, and tails. Or if an adult cuts simple shapes from the skins—a tail, some legs, an oval for a body, ears—kids can assemble them into creatures. Have little ones play with their pieces a bit before deciding to glue them down permanently.

MYSTICAL POTION PAINTING

PAINT IS A BIT MAGICAL. IT CAN TRANSFORM ANY SURFACE INTO SOMETHING SPECIAL TO LOOK AT. So why not experiment with that magic and create a swirling potion of textures and colors? In this exercise, you will see humble watercolor, salt, glitter, and dyes as enchanted ingredients. Stir, fleck, sprinkle, drip, and brew up a potion of your own. This is all about being free in the process, trusting your creativity, and discovering happy surprises along the way.

MATERIALS

→ Watercolor paper

→ Masking tape

→ Watercolor paint

→ Glitter paint

→ Paintbrush

→ Packets of iridescent glitter

→ Coarse salt

→ Powdered fabric dye

→ Rubbing alcohol

→ Rigid work surface: wood board for cardboard

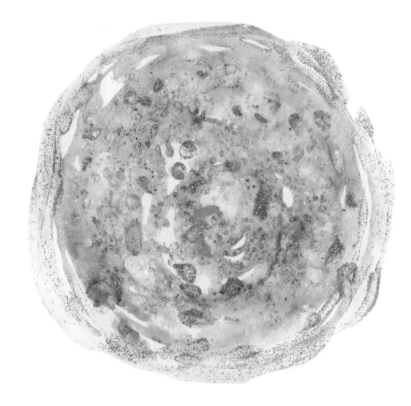

Let's Go!

Prepare ahead (optional): Fill a shaker or two with a combination of coarse salt and some granules of powdered dye. Fill another shaker with iridescent glitter. You could sprinkle these items by hand, but it adds to the fun to mix your potions ahead of time and add them with flair right from the containers.

1. Tape the paper to your work surface. Use diluted watercolor paint to make a loose, loopy, imperfect circle (fig. 1). Leave gaps in the circle, painting in a spiral motion. Drop in concentrated watercolor paint using the brush, and then tilt and tip the paper to encourage swirling and blending of colors. Be careful not to blend too much.

2. Dust some of the salt and dye potion onto the wet circle (fig. 2). The dye granules will bleed and spread color; the salt will soak up color and leave a texture of tiny light speckles.

3. Use a brush to add concentrated drops of watercolor paint and globs and streaks of glitter paint (fig. 3). The bright watercolor drops will splinter and spread. The glitter paint adds sparkle. Have fun and follow your intuition. Express yourself in whatever way feels magical to you.

4. Add a sprinkle of rubbing alcohol by flicking a paintbrush over the wet paint (fig. 4). Watch closely as the colors retreat and spread away from the alcohol. It's amazing! Then, finish with a final dusting of glitter.

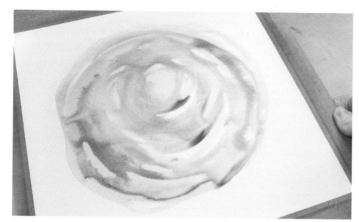

Fig. 1: *Paint a watery spiral and swirl the watercolors.*

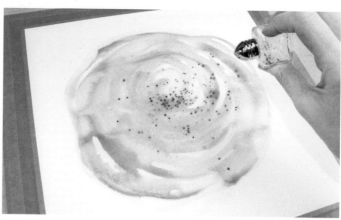

Fig. 2: *Sprinkle on coarse salt and dye.*

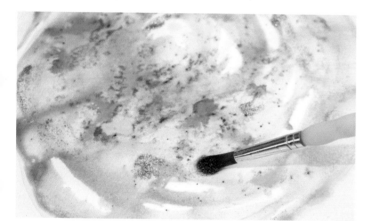

Fig. 3: *Add bright watercolor and glitter paint.*

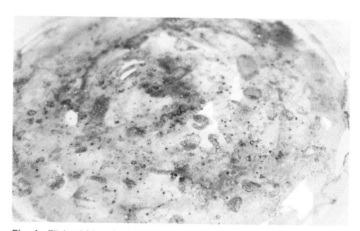

Fig. 4: *Flick rubbing alcohol onto the painting and add glitter.*

Inspiring Artist: Peter H. Reynolds

When it comes to encouraging kids to own their creativity and make their mark, Peter H. Reynolds leads the way. Peter has inspired millions with his many children's books and endearing illustrations. His book, *The Dot*, and his International Dot Day initiative have given voice to the creativity of children all over the world, letting them know that their talents and gifts are wonderful and should be shared. Learn more at peterhreynolds.com.

A Dot by Peter H. Reynolds

Practice, Practice!

—Practice using even more concoctions. Add drops of food coloring. Sprinkle with colored sugar or with the shavings from your sharpened watercolor pencils. See how many ingredients you can come up with.

—Try adding diluted acrylic or craft paints. Add drops of white onto the areas of wet color and see what happens. What kind of color blending can you achieve with multiple layers of paint?

QUIRKY PET PORTRAIT

MATERIALS

→ Heavyweight art paper

→ Photograph of your pet for reference

→ Light box (optional)

→ Permanent ink pen

→ Tempera or craft paint

→ Paintbrushes

→ Paper palette or coated paper plate

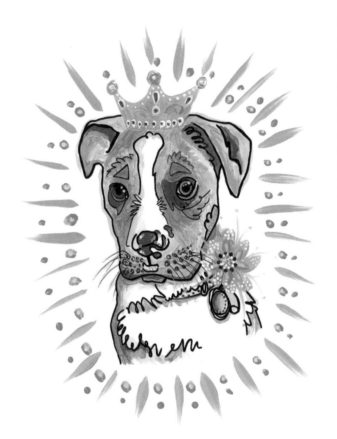

USE YOUR IMAGINATION TO PAINT A STYLIZED PET PORTRAIT WITH SIMPLE LINES, VIVID COLOR, AND WHIMSICAL TOUCHES. Rather than making a realistic painting of your favorite pooch, aim for an artwork that expresses personality and uses crazy color. Is your pet quirky? Add a mustache. Does your pet love rolling in the flower garden? Give him a wild flower garland around his neck. Is your doggie super happy and full of fun? Add a big smile and a silly hat. Let your imagination guide your choices in this fun exercise.

Let's Go!

1. Draw (or use a light box to trace) the basic head shape and features of your chosen pet with a permanent black pen or marker (fig. 1).

2. Add paint in a dark color of your choice to any area that looks dark on the reference photo (fig. 2). You will use this color for all areas that appear almost black in the photo. You will not paint areas that show up white or extremely light in the photo.

3. Add a few colors of medium-toned paint in whatever way you wish (fig. 3). Just be sure to leave your darks dark and the light areas blank. Choose vibrant colors and have fun with it. Let your brushstrokes be a bit messy and expressive. Add dots and pattern, if you like.

4. Draw extra accessories on the painting (fig. 4). Think about your pet's personality. Would a funny hat be fitting? How about a sparkly necklace, a shirt and tie, or maybe glasses? Match the accessories to your pet.

5. Paint a background design around the pet (fig. 5). You can try stripes, flowers, scribbles, or even your pet's name. Go back over the outline with your marker if you wish to tidy up any places where paint has gone astray.

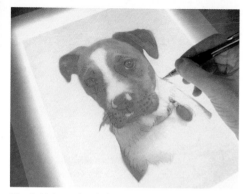

Fig. 1: *Make a simple line drawing of your pet, (freehand or by tracing with a lightbox as shown).*

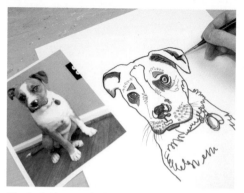

Fig. 2: *Add some dark paint to shadowy areas.*

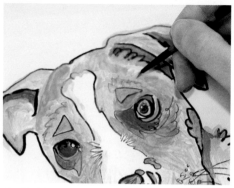

Fig. 3: *Add paint in a medium tone.*

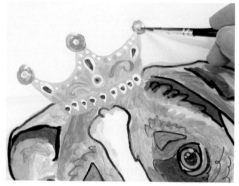

Fig. 4: *Add whimsical touches.*

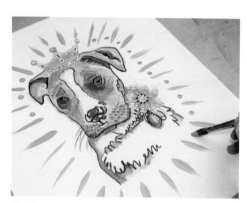

Fig. 5: *Add some background decoration.*

Inspiring Artist: Jo Chambers

This perfectly quirky example of pet portraiture is by Jo Chambers of Studio Legohead. Jo has drawn attention around the world since 2011 with her unique ability to capture the personality and humor of canines. Her contemporary take on pet portraiture is widely admired and continues to grow. To see more of Jo's charming, colorful, and endearing pet illustrations, visit studio-legohead.com.

Pug in Pucci by Jo Chambers/Studio Legohead

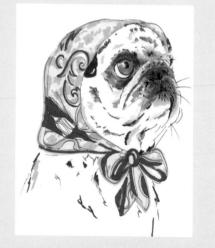

Little Hands

Portraits with any sort of realism are beyond the ability of most small children, but their version can be just as precious. Encourage little ones to use simple shapes to draw their puppy or kitty or turtle. Then prompt them to choose colors that represent the animal. Ask, "Is Rocket happy? What color should we use to show happiness?" The children will catch on quickly and revel in coloring the puppy purple with orange polka dots or any combination that suits them.

PAINTING ON WATER:
Marbled Paper Galaxy Painting

PAPER MARBLING IS AN ANCIENT CRAFT IN WHICH PAINT IS FLOATED ON THE SURFACE OF WATER, SWIRLED INTO BEAUTIFUL PATTERNS, AND THEN TRANSFERRED TO PAPER.

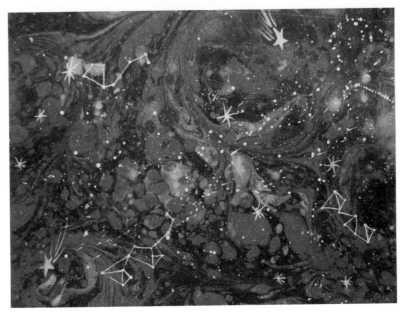

The fluid effects of marbled paper are mesmerizing. Use this kid-safe version of the marbling technique to create a magical galaxy painting flecked with bright stars.

MATERIALS

→ 2 shallow pans (slightly larger than your cardstock)

→ Liquid starch (Stay-Flo is thick and helps the paint float.)

→ Craft paint in black, electric blue, and two bright colors of your choice

→ 4 small cups or bowls for mixing paint

→ Smooth card-stock in dark, outerspace colors

→ Paintbrush with stiff bristles

→ Small round paintbrush

→ Waxed paper (for drying)

→ Toothbrush

→ Craft paint in white (or glow-in-the-dark paint)

Let's Go!

1. Cover the bottom of one pan with the liquid starch for marbling, and fill the other halfway with clean water, for rinsing (fig. 1).

2. Mix a very small amount of water with each paint color to achieve a thick, creamlike consistency that's *just* pourable and will float on top of the starch. Paint that's too thick or too thin will sink. Do a test by dripping a little onto the starch. The goal is to use the thickest consistency that will still float.

3. Pour drips and puddles of the paints onto the starch. Touch the paintbrush down lightly and drag swirls through the colors (fig. 2). Finish with black and make more swirls. Try to make patterns that resemble outer space. Flick some extra speckles of the lighter colors over the swirls. This is the key to the galaxy look!

4. Gently lay a sheet of cardstock on the paint surface, ensuring all of the edges make contact (fig. 3).

5. Peel the paper up immediately (fig. 4) and slide it into the pan of clean water to rinse the starch. You'll have to give it a shake. It may look streaky at first, but that's just the starch. Once rinsed, you'll see your swirled pattern. You will be able to pull three or four prints per paint application from the starch pan.

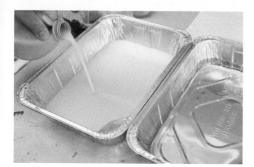

Fig. 1: *Put starch in one pan and water in the other.*

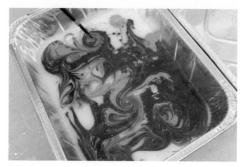

Fig. 2: *Add thinned paint colors to the surface. Gently swirl and move the colors to avoid overblending.*

Fig. 3: *Place the cardstock into the marbling pan and tap the corners down.*

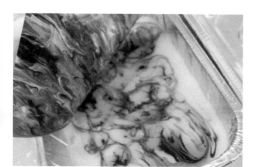

Fig. 4: *Carefully lift a corner of the paper, remove it from the pan, and then rinse.*

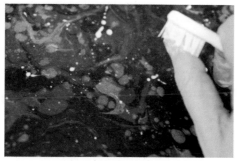

Fig. 5: *Flick and spritz the galaxy with stars.*

6. Place the marbled paper on waxed paper or another nonporous surface to prevent sticking as it dries.

7. Once dry, finish off your swirled galaxy painting by flecking on some white stars with the toothbrush (fig. 5). Add planets, rockets, shooting stars, and constellations. Add some glow-in-the dark paint also for a fun effect!

Inspiring Artist: Alicia Ferrara

Alicia Ferrara is a young artist and entrepreneur with a fascination for surreal and psychedelic art. At only 18 years old, she has opened her own business selling beautiful marbled T-shirts. She creates each one-of-a-kind tee by hand, full of swirls and vibrant color. And she proves just how versatile the marbling technique can be. See more of Alicia's tees at etsy.com/shop/TotallyTiedAndDyed.

Outer Space Marbled T-Shirt by Alicia Ferrara

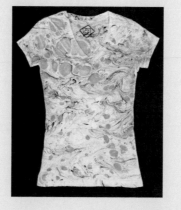

Little Hands

This project requires dexterity and speed because the paper will get soggy and fragile quickly. I've found the best way to do this with toddlers is to work small. Use a small loaf pan and trading card-size bits of cardstock. You'll use less paint and have more manageable-size cards to dip and retrieve. Little ones can swirl the paint design, drop the card in, and then shimmy the water bath. Grown-ups do the rest. Once dry, try using star stamps instead of a paintbrush to add details.

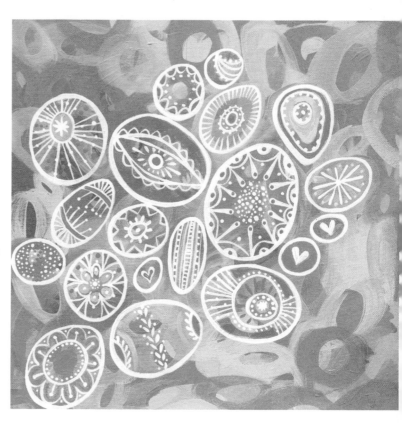

LAB 18

DOODLE ON A PAINTING

MATERIALS

→ Stretched canvas or canvas paper

→ Craft paint

→ Paintbrushes

→ Paper palette or coated paper plate

→ Paint pen (optional)

Little Hands

Small brushes and detailed painting can be tough for small kids. For a similar concept, but simpler execution, try making a colorful watercolor background with them instead and have them doodle on top with marker or a paint pen. Scribbles are a perfectly acceptable form of doodles for young kids, and they will be so proud to share them with you.

A GREAT WAY TO TRANSITION A LOVE OF DRAWING TO A LOVE OF PAINTING IS TO START BY COMBINING THE TWO. Kids can be free and expressive while creating a colorful painting with an abstract background. Then they can show their more meticulous skills by using a fine brush to make doodles on top. The result is a perfect combination of bold color and intricate detail that fit together perfectly.

Let's Go!

1. Paint a quick background by scribbling in sections of bold colors (fig. 1). Have three or four colors on your palette and alternate randomly between them as you work. This establishes a colorful ground so that there will be no empty spaces or holes when the next layer is added.

2. Once the canvas is covered, use the same colors to paint a second layer of circles and overlapping ovals (fig. 2). Alternate between the colors to achieve a nice balance. This gives an interesting background texture on which to make your doodles.

3. Once the canvas is dry, use a fine brush and white paint to add a variety of different sized circles (fig. 3). Don't strive for perfect circles. Wobbly, oblong shapes are just perfect. Doodle something different inside each circle. Try not to repeat the same design twice. Be creative!

4. Use a fine brush to add fun painted accent colors to some of the doodles for interest (fig. 4).

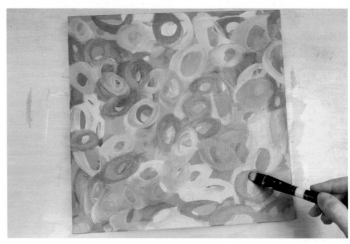

Fig. 1: *Paint a scribble background.*

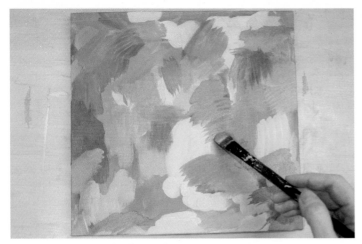

Fig. 2: *Paint a layer of circles. Let dry.*

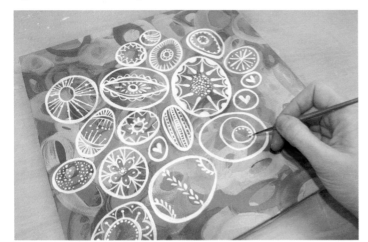

Fig. 3: *Add doodles.*

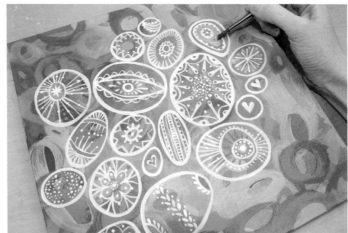

Fig. 4: *Add color to the doodles.*

Author's Inspiration

Round doodles feature heavily in my work. There is something so complete and happy about a circle filled with decorations. For this painting, I explored all the ways I could think of to doodle a seedpod. Coming up with lots of different designs inside each circle or oval was a fun challenge. Try doodling some circles onto your next painting. You won't be able to stop!

Pods + Blossoms by Stephanie Corfee

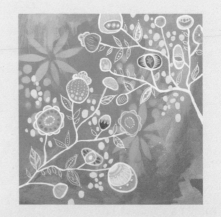

PAINTING FLOWERS AND LEAVES IS GREAT PRACTICE FOR MAKING BOLD, CONFIDENT BRUSHSTROKES. Paint a make-believe garden filled with imaginative plant life. Paint flowers, leaves, grasses, cacti, even a Venus flytrap using only simple shapes you can make with one swipe of the brush.

MATERIALS

→ Heavy drawing paper

→ Craft or tempera paints

→ Paintbrushes: a filbert brush, which has a flat ferrule (the metal part where the bristles are attached) and rounded bristles, and a round brush, which has a round ferrule and blunt bristles

→ Paper palette or coated paper plate

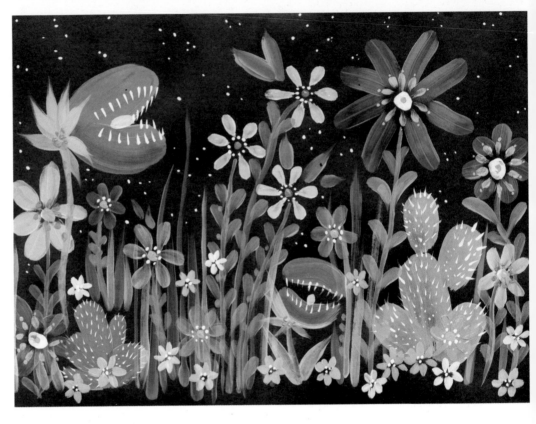

Let's Go!

1. To paint the flowers, make a dot for the center, then press down with the brush for each petal, and lift as you pull toward the center. Make leaves the same way, using green paint (fig. 1).

2. To paint grass and stems, press down at the base and lift the brush as you pull upward in a long stroke (fig. 2).

3. To paint the cacti, make a stack of bold ovals with a wide brush and add lots of tiny lines for the prickly hairs (fig. 3).

4. Paint the Venus flytrap by making two ovals arranged like a *V* and add spikey teeth (fig. 4). Combine these simple plants in many colors and sizes to create an amazing garden.

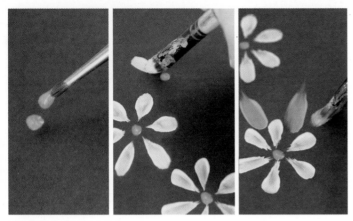

Fig. 1: *Paint flower petals.*

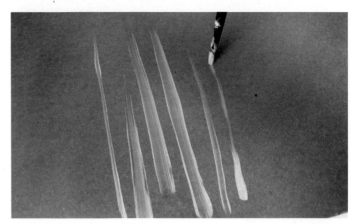

Fig. 2: *Paint the grass and stems.*

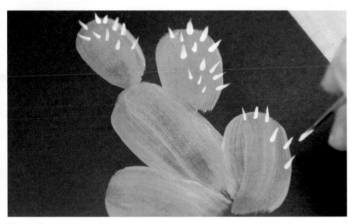

Fig. 3: *Paint the cacti.*

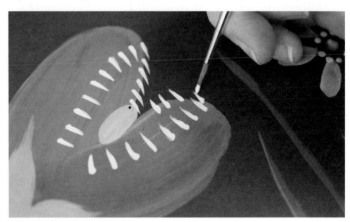

Fig. 4: *Paint the Venus flytrap.*

Author's Inspiration

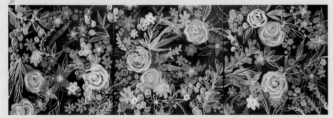

Merle's Treasured Garden by Stephanie Corfee

This *triptych*, (an image on three panels), is one of my favorite examples of brush-stroke blooms ever. It was commissioned to honor an amazing artist who had a deep love for colorful blossoms herself. It features hand-painted three-dimensional Lucite flowers that she had used in her exquisite beading work. Isn't it amazing how a colorful floral like this can change your mood? It's practically impossible not to smile when you're creating flowers.

Little Hands

With very little kids, focus on simple daisies, dots, and stems. To make petal-making easier, use a round-tipped (filbert) brush, which can be pressed down and pulled up on the page to create a nice plump petal. Turned on its side, a filbert can also make great slim, wobbly stems. Work on three daisies in fun colors, side by side on the page. Rotate the page as you draw each group of petals so your child won't have to change their wrist position as they master the petal-painting technique.

BUBBLY PRINT BALLOONS

MATERIALS

→ 3 mason jars or similar size cups or bowls

→ Liquid dish soap

→ Tempera paint

→ Drinking straws

→ Heavyweight white paper

→ Pens or markers

→ Paintbrushes

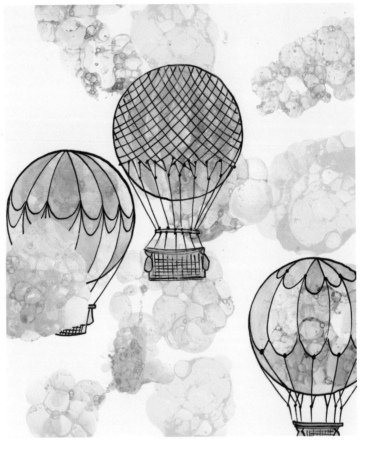

WATER-SOLUBLE PAINTS OPEN UP A WORLD OF POSSIBILITIES. You can drop them, swirl them, spray them, and even make bubbles with them. In this exercise, make stunning and intricate bubble prints using just straws, paint, and dish soap. It's so simple, but yields truly impressive results. And cleanup is a snap.

Let's Go!

1. To make the bubble paint solution, mix two tablespoons tempera paint, two tablespoons dish soap, and four tablespoons water in a mason jar or similar size container (fig. 1). Make three different colors.

2. Use one, two, or three straws to blow bubbles that overflow the cup (fig. 2). Using more straws results in more individual bubbles. Note: Make sure your child knows how to blow *into* a straw by practicing in a cup of plain water. The paint and soap should not be ingested.

3. Touch the paper gently onto the bubbles to make an impression (fig. 3). Repeat making bubbles and imprinting the paper until you like the result. Scatter your imprints on the paper with space between.

4. Once the paper is dry, use a pen or thin paintbrush to add details and embellishments that will transform your bubble prints into hot air balloons (fig. 4).

5. OPTIONAL: Add extra bits of color to your artwork if you like.

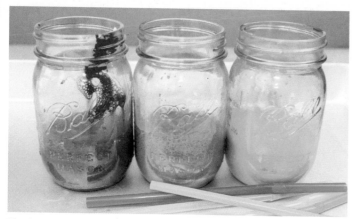
Fig. 1: *Mix the bubble paint solution.*

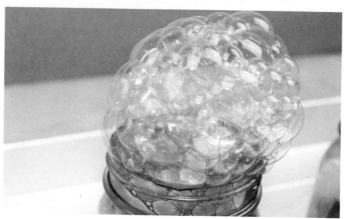
Fig. 2: *Blow bubbles.*

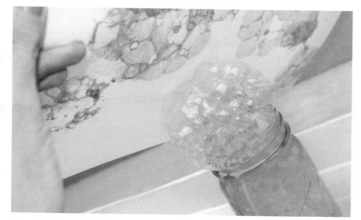
Fig. 3: *Print the bubbles onto the paper. Let dry.*

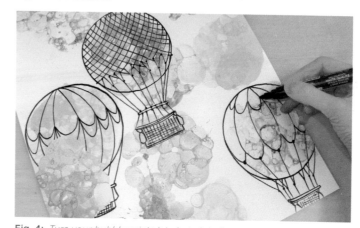
Fig. 4: *Turn your bubble prints into hot air balloons.*

Inspiring Artist: Jasmine Nixon

This beautiful notebook by Jasmine Nixon is one example of the things you can do with bubble-printed paper. Jasmine is an experimental, self-taught bookbinder. She creates and sells handcrafted journals that incorporate a wide variety of processes, materials, and inspirations, including spray painting, bubble printing, and acrylics. See more of Jasmine's work at etsy.com/shop/xnotedx.

Handmade Bubble Print Notebook by Jasmine Nixon

Little Hands

It is so important that your child blow *out*, not suck *in* on the straws. With a little one, try blowing a paint solution through a bubble wand onto a piece of paper. Just mix some tempera paint into store-bought bubble solution, dip the wand, and have your little one "blow kisses" onto the page. Give the finished art to grandparents with a big "xoxo" signature at the bottom. (It's best to work on this project outdoors or in a controlled environment with drop cloths to prevent getting paint on furnishings.)

LAB 21

IF I HAD WINGS:
Decorative Painting

MATERIALS

→ Heavyweight white paper

→ Pencil

→ Marker or paint pen for outlining

→ Watercolor paint

→ Craft paint

→ Paintbrushes

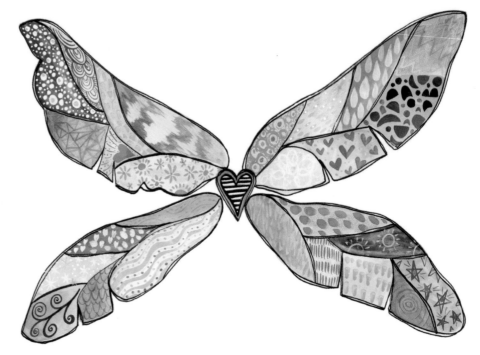

IT IS SO BEAUTIFUL TO SEE WHAT WILL SPRING FROM A CHILD'S IMAGINATION WHEN NO RULES ARE SET ABOUT PAINTING REALISTICALLY. It gives them wings! In this lesson, kids will imagine they have wings. What would those wings look like? It's make-believe. They can have flowers, swirls, doodles, or words. The idea is to ignore reality and use whatever fantastic decorations arise from their imagination.

Let's Go!

1. Draw the outline of the wings on large paper using pencil (fig. 1). For inspiration, think about butterflies, birds, fairies, dragonflies, or create a combination of your own. Draw some lines to create sections within the wings so you can decorate in a patchwork style.

2. Paint solid colors in the main wing shapes with a flat brush (fig. 2). Allow to dry.

3. Use your imagination to decorate the wings with lots of color and a small brush (fig. 3). Try polka dots, leaves, stripes, and zigzags.

4. OPTIONAL: Cut out your wings and hang them on the wall or wear them if you like!

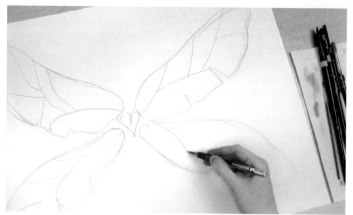
Fig. 1: *Draw the wing shapes.*

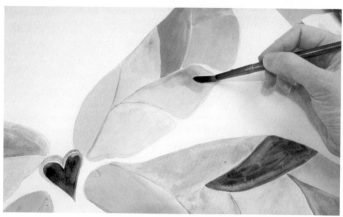
Fig. 2: *Paint the large areas. Let dry.*

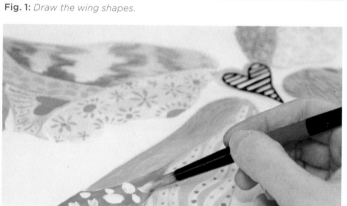
Fig. 3: *Add painted decorations.*

Inspiring Artist: Bari J. Ackerman
of Bari J.

This stylish sea turtle by Bari J. is a wonderful example of decorative painting. In addition to painting, Bari is a well-known fabric designer. Her whimsical designs and eye for pattern and color have resulted in successful collections for Art Gallery Fabrics. She has created many sewing patterns and has written a book, *Inspired to Sew.* Her work, including wall art, fabric, home décor, and stationery, has been featured in both national and international magazines. See more at barijdesigns.com.

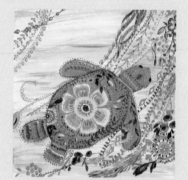
Boho Sea Turtle by Bari J.

Little Hands

Very small children will lack the dexterity and control needed for the detail work in this exercise. To include them while older kids are working, have them embellish their wings with a few mini stamps that you have carved into pencil erasers beforehand. You can make a simple flower, heart, and square. And the pencil eraser itself makes perfect polka dots.

LAB 22

WHOLE WORLD IN YOUR HAND: Painting in Miniature

MATERIALS

→ Card stock

→ Tempera or craft paint

→ Scissors

→ Paintbrushes

→ Paint pens or marker

→ Paper palette or coated paper plate

→ Watercolor paint

→ Glue

→ Short length of sturdy wire

→ Air-dry clay

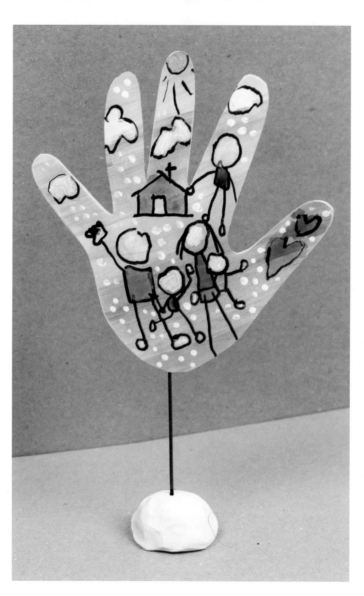

THERE IS SOMETHING SO PRECIOUS ABOUT ART IN MINIATURE—AND IT IS ESPECIALLY SWEET WHEN KIDS MAKE IT. Here kids will paint their world, or their family, on a tracing of their hand using small detail brushes or a paint pen. The finished art is colored with more paint and then mounted to create a meaningful keepsake.

Let's Go!

1. Paint a streaky sky onto card stock with tempera paints (fig. 1).

2. When the sky is dry, trace your hand over the painted area. Cut it out (fig. 2).

3. Use small detail brushes or a paint pen to draw your family, your school, or whatever is important to you (fig. 3). Use watercolor, craft paint, and small detail brushes to add color to your drawings. Watercolor will add transparent color that won't obscure outlines. Craft paint will create more opaque colors.

4. Trace the painted hand onto blank card stock and trim it. Glue the two hand shapes together with a length of wire sandwiched between them (fig. 4). Insert the wire into a small bit of air-dry clay.

Fig. 1: *Paint the sky. Let dry.*

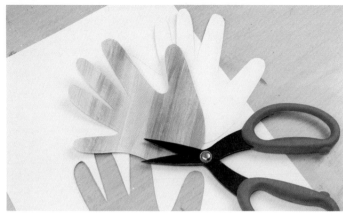

Fig. 2: *Trace your hand and trim around it.*

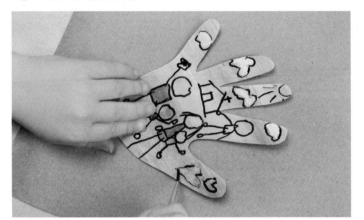

Fig. 3: *Paint your world.*

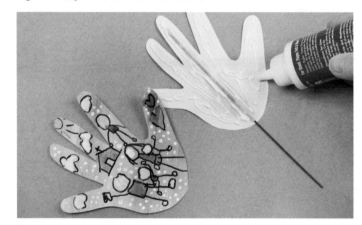

Fig. 4: *Mount your artwork.*

Inspiring Artist: Carolina Coto

Here is a stunning example of a mini painting by Carolina Coto. Carolina is a Costa Rican artist now residing in the United States. Her work is filled with bright colors and whimsical scenes, as well as repetitive elements like dots, circles, and spirals, all signifying hope, positivity, dreams, and joy. Discover more of Carolina's work by visiting carocoto.com.

Little Barn Necklace by Carolina Coto

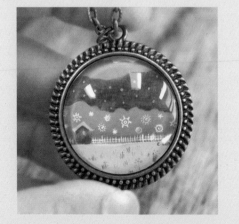

Practice, Practice!

—Try painting small objects such as leaves, small stones, and old gift cards with color and detail. Use cookie cutters to make shapes with air-dry clay and paint on those as well.

—For some *really* itty-bitty art, paint shrink plastic with acrylic paint and then shrink your art to about half the size. You can use these tiny masterpieces in craft projects or give them as gifts.

UNIT 04

PALETTE PLAY:
Color-Based Labs

COLOR IS POWERFUL. IT CAN CONVEY MOOD, ENERGY, STRENGTH, CALM, OR DISCORD. Opposite colors on the color wheel, called complementary colors, provide contrast and energy. Neighboring colors on the color wheel, called analogous colors, are harmonious.

In this unit, learn about ways to strategically apply color for different effects. Energize with contrast and soothe with subtle color gradation. Learn about blending techniques for both watercolor and acrylic. Discover how to layer colors so they retain their pop. So much success in painting comes from really understanding the media and knowing how to handle and manipulate it. Set yourself up to succeed!

In addition to the application of color, learn how balancing colors in a composition can change the entire personality of the artwork. Explore color combinations outside your comfort zone. Blend new tints and shades like a pro. All these techniques will give your paintings a depth and style that elevates them to a whole new place. Start to really see color in the world around you and find inspiration in the color combinations you observe.

Understand, appreciate, and be in control of the paint palette!

ENERGY BURST:
High-Contrast Minimalist Painting

THERE ARE MANY WAYS YOU CAN USE COLOR AND CONTRAST TO CREATE A HIGH-ENERGY VIBE IN YOUR PAINTINGS. Contrasting colors, bold brushstrokes, and bright colors are just a few. In this exercise, create a painting that is humming with life by using a combination of bold streaks of bright color, with sharp black and white shapes and doodles on top.

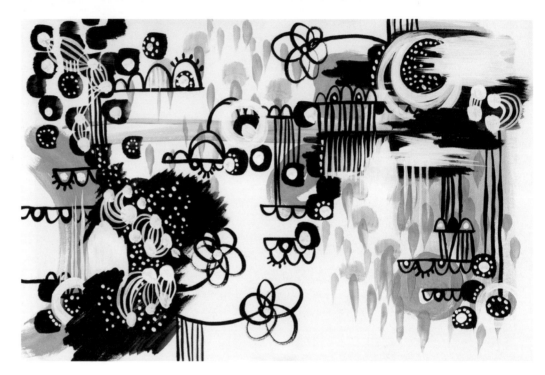

MATERIALS

→ Heavyweight white paper

→ Acrylic paint

→ Paintbrushes

Let's Go!

1. Think about layout and composition first. Will you have pink on the right? Green in the middle? Once you have decided, confidently swipe the colored paint onto the page (fig. 1). Don't fuss over it. Work quickly and confidently. Allow to dry.

2. Repeat step 1, but use black paint (fig. 2). Be bold! Let dry.

3. With a fine brush, paint some fun black doodles (fig. 3). Make some solid and leave some as outline only. Again, don't be overly fussy. It's more important to follow your instincts and not second-guess yourself.

4. Let dry, then add pops of opaque white paint (fig. 4). You can add pattern or fill in the doodles. Or you can just add a few floating white chunks or dots. Keep up that energy!

How do you feel? Did you have fun? It will show in your art!

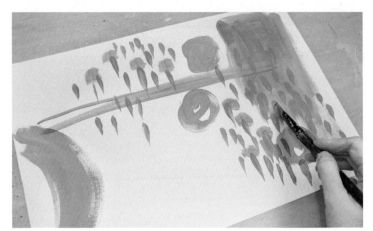

Fig. 1: *Paint expressive chunks of bright color. Let dry.*

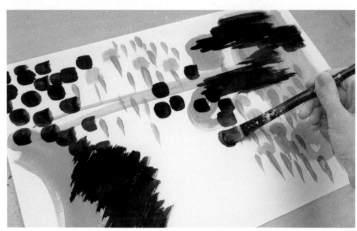

Fig. 2: *Paint sections of black. Let dry.*

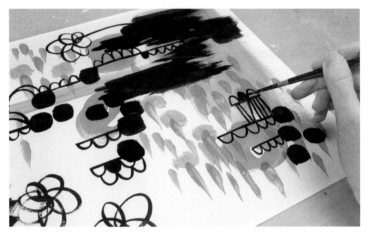

Fig. 3: *Add black doodles. Let dry.*

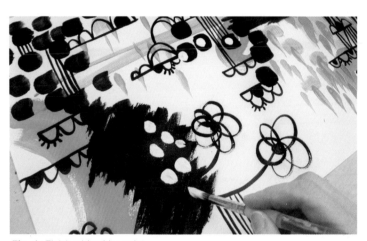

Fig. 4: *Finish with white paint.*

Inspiring Artist: Zoë Ingram

This sketchbook spread by Zoë Ingram is just buzzing with energy! Zoë is a British-born illustrator and designer now living with her family in Australia. Her work is lush, playful, and organic—with a twist. She has a deep love affair with color. Zoë often uses hand lettering, layering, and a variety of textures in her work, combining traditional methods with digital finishing. To see and learn more, visit zoeingram.com.

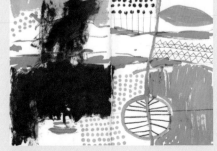

"82" by Zoë Ingram

Little Hands

Help very young children work on this painting by offering only one color paint at a time and allowing each layer to dry completely before beginning the next. The pop and contrast come as much from the color choice as from the complete lack of blending. Little kids have an advantage here because they are completely expressive and spontaneous in their work. The result is bound to be wonderful.

OMBRÉ OCEAN

MATERIALS

→ Watercolor paper

→ Watercolor paint

→ Paintbrushes

→ Pencil

→ Gouache or craft paint

OMBRÉ IS JUST A FANCY WORD THAT DESCRIBES A COLOR THAT VARIES IN TONE FROM LIGHT TO DARK. Using several transparent layers of watercolor washes to build up color and saturation is a great way to achieve this effect. In this lesson, create your own ombré ocean in a bottle. Paint incrementally more concentrated layers of transparent watercolor onto damp watercolor paper to create a gradual darkening effect. Add fish, coral, and bubbles using tempera or gouache to finish the piece.

Let's Go!

1. Mix some watercolor pigment with water to get a dilute, pale wash (fig. 1).

2. Sketch a simple bottle shape with light pencil. Use a very wet brush to paint inside the outline with a very pale wash of watercolor(fig. 2). Pay close attention to the edges and get the paper shiny-wet, but avoid pooling water.

3. Turn the painting upside down. Add a bit more pigment to the diluted watercolor wash and sweep a stroke along the bottom edge of the bottle (fig. 3). Tilt the paper to help the wash to flow downward.

4. Continue to add more and more concentrated washes as you did in step 3. Continue to dampen the bottle area as necessary to allow the color to spread (fig. 4). Some of the water may pool at the bottom edge. Blot it lightly with a paper towel.

5. Once the ombré watercolor is dry, use gouache to paint some starfish, bubbles, coral, and, other underwater elements (fig. 5).

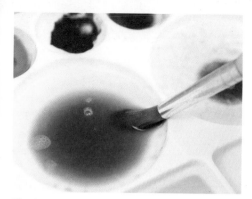

Fig. 1: *Mix diluted watercolor.*

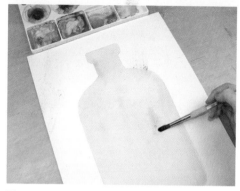

Fig. 2: *Sketch a bottle with pencil and paint it with the wash.*

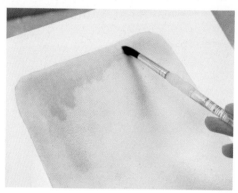

Fig. 3: *Flip the paper, apply a darker wash, and tilt the paper.*

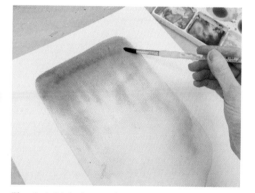

Fig. 4: *Add darker washes. Let dry.*

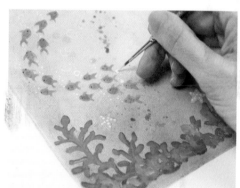

Fig. 5: *Add sea life.*

Inspiring Artist: Heather Volkel

Ombréd blues look stunning in this painting by Heather Volkel. Heather has enjoyed painting from a young age and seeks inspiration from the beautiful mountains of Colorado. She loves working with watercolors and watching the colors blend together. Heather can often be found dancing around the kitchen with her husband, daughter, and their silly dog. See more of Heather's work at etsy.com/shop/SomewhereFound.

Winter Ombré Tree by Heather Volkel

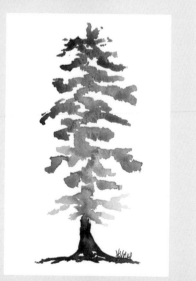

Practice, Practice!

—An ombré effect is striking to use as a fill for all types of shapes. Try painting recognizable animal silhouettes using this technique.

—Try combining two ombré colors that meet in the middle and blend. This can result in a beautiful sunset effect, a great background for a landscape painting.

PENCIL ERASER POINTILLISM

MATERIALS

→ Card stock

→ Pencil

→ Scissors

→ Masking tape or painter's tape

→ Canvas paper

→ Craft paint

→ Paper palette or coated paper plate

→ 3 pencils with new erasers

POINTILLISM IS A PAINTING TECHNIQUE THAT USES DOTS INSTEAD OF BRUSHSTROKES TO APPLY COLOR. Clustering different colored dots can give the effect of a blended color to the eyes. In this exercise, make a multicolor painting of your initial using only primary colored dots applied with a pencil eraser. Note how different color combinations and placement will appear to be blended color to your eye when you step back from your work.

Let's Go!

1. Draw a freehand letter shape or trace a large initial printed from your computer onto a piece of cardstock. Cut out the shape to create a stencil (fig. 1).

2. Use small pieces of masking tape rolled into tubes to hold the stencil in place on the canvas paper (fig. 2).

3. Squirt primary paint colors onto your palette and use a fresh pencil for each color. Make dots in the stencil shape (fig. 3). Apply a single color to different areas to start.

4. Begin mingling the adjacent colors together (fig. 4). Overlap the dots. Cluster them more and more tightly together until you are happy with the mix and balance of colors.

5. Remove the stencil to reveal your letter.

Fig. 1: *Sketch and cut out your initial.*

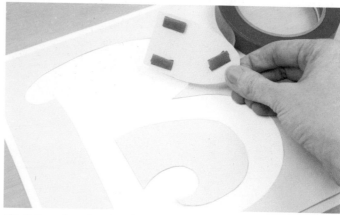
Fig. 2: *Tape down the stencil.*

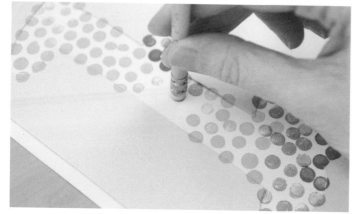
Fig. 3: *Make dots with pencil erasers.*

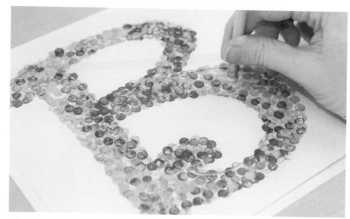
Fig. 4: *Make layers of colored dots.*

Inspiring Artist: Asta Kundelytė

Freelance artist Asta Kundelytė demonstrates just how amazing painted dots can be! Colorful and playful paintings dominate Asta's portfolio. "Warm and bright colors help me to express warm feelings and good emotions that I want to share with the viewers. I like to play with colors the most." See more of Asta's work at artbyasta.com.

Sunny Day by Asta Kundelytė

Practice, Practice!

—For a fun twist, try masking off simple, solid shapes and painting *around* them instead of inside them.

—Try creating dot paintings of simple objects. Use clusters of different colored dots to get the effect of shading, as necessary.

PARTNER PAINT-BY-NUMBER

MATERIALS

→ Heavy white paper

→ Craft paint

→ Permanent marker

→ Paintbrushes in various sizes

Practice, Practice!

—Make paint-by-number portraits with your best friend, and then swap portraits to paint them.

—Use this paint-by-number technique to decorate canvas sneakers. Wear your art on your feet!

HAVING AN OPEN MIND HELPS TO ENCOURAGE YOUR CREATIVITY. Be open to new color combinations in this fun exercise that you work on with a friend or family member. Create an eight-color key and assign a number to each color. Each partner creates a wandering pencil doodle and assigns a number between one and eight to each section of their drawing. Swap drawings with your partner and paint by number. You're sure to create some color combinations you probably wouldn't have tried on your own. These paintings make a great keepsake that will remind you of special people and fun times.

Let's Go!

1. Make a color key by painting swatches of eight different colors on a piece of scrap paper (fig. 1). Number each of the colors.

2. Use a permanent black pen or marker to draw a freeform doodle with overlapping loops, angles, and lines (fig. 2). For a fun twist, you can even try this with your eyes closed. End the doodle back at your starting point and make sure you have plenty of enclosed areas for the paint. Your partner should draw one, too.

3. With a light pencil, number each enclosed section of the doodle with a number from one to eight (fig. 3). You can leave some sections blank if you like. Negative space is a nice rest for the eye in an artwork full of bold colors.

4. Trade doodles with your partner and get to work painting the sections according to the color key (fig. 4). Once all the solid areas are painted, add a few doodles or textures if you like. You can trade back or keep your own work.

Fig. 1: *Make the key.*

Fig. 2: *Draw the doodle.*

Fig. 3: *Assign the numbers.*

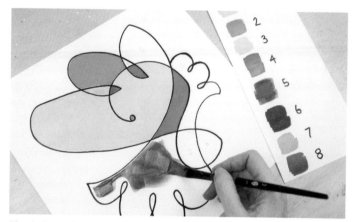

Fig. 4: *Swap the doodles and paint.*

Inspiring Artist: Patti Robrahn

Creating doodles for coloring is an art form for Patti Robrahn, as shown by this whimsical piece. "I first drew swirling coloring pages for my two young daughters, just like my mother had drawn for me. I found the doodle drawings sparked my own creativity and challenged me to see beyond the page to the whimsical creature hiding in the lines." Discover more of Patti's vibrant doodles at etsy.com/shop/spyingonmermaids.

Kissy Fish by Patti Robrahn

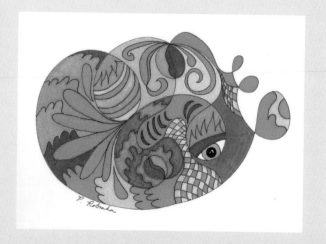

THERE IS A FREEDOM AND SPONTANEITY THAT COMES FROM WORKING QUICKLY AND BY INTUITION. One way to encourage this is to work on a multiple pieces of artwork at once. In this exercise, use one color palette to simultaneously create six paintings with varying composition, balance, and scale. Each square becomes less precious when you work on many at the same time. You won't have time to overthink every decision, so the results are very authentic and true to your artist's heart.

MATERIALS

→ Heavy white paper

→ Scissors

→ Large board for support, such as corkboard or scrap wood

→ Tape or tacks

→ Acrylic paint in 3 colors

→ Paintbrushes

→ Paper palette or coated paper plate

Let's Go!

1. Trim heavyweight paper into six identical squares (fig. 1). Squares work well here because the finished paintings can be turned in any direction for framing, which can be helpful to the overall balance of the group. Tack or tape the squares to a large piece of cardboard, corkboard, or scrap wood.

2. Begin painting with the first color (fig. 2). Spend only a minute or two on each square. Change the placement, shape, or amount of color that you use on each paper. Paint one piece with small dots in the center, and then the next with a large circle made with a bold brushstroke. Mix it up. This is the time to experiment. There are six opportunities to try something different, so go for it!

3. Allow to dry, then add the second color using the same idea (fig. 3). Change up the composition, the layering, and the brushstrokes. Solid areas of color are nice to try if an outline was painted in the first layer. Small dots will be balanced out with larger shapes. Listen to your gut and work quickly without thinking too much. Just paint what feels right. Let dry.

4. Try adding a unifying element to each painting with the last color (fig. 4). If circles, dots, and strokes are your major elements, finish each painting with one of these elements that might be missing. Using similar shapes and forms in different ways can be a strong unifying factor across your collection. Place the final elements where they will add balance or movement.

Now, look at each painting individually. Did you end up with a few you dislike? Are there some that you love? Pick out the best and hang them together. Paint over the rest or cut them up to use in a future collage project.

Fig. 1: *Cut and tack up six blank squares.*

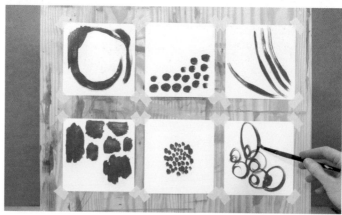

Fig. 2: *Apply the first of three colors. Let dry.*

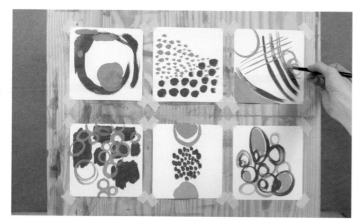

Fig. 3: *Apply the second color. Let dry.*

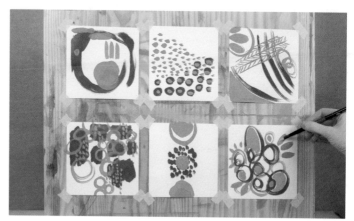

Fig. 4: *Apply the third color. Let dry.*

Inspiring Artist: Renae Schoeffel

This stunning example of a cohesive mini collection is by self-taught abstract artist Renae Schoeffel. Note the consistent color story and varied compositions. Renae's mission as an artist is to inspire and to create something you

Seelie Court by Renae Schoeffel

can escape to, meditate in, dream with, and contemplate over time. To see more of Renae's colorful and expressive work, visit etsy.com/shop/renaeschoeffelart.

Practice, Practice!

—Plan a collection based on scale. Paint only small elements on one canvas, medium shapes on another, and large areas of color on a third. Which do you like best?

—Try a collection based on shapes such as a variety of circle paintings. Some circles can be outlines, some can be filled, some solo, and some in groups. There are so many ways to vary a theme.

MATERIALS

→ Watercolor paper

→ Cardboard paper towel tube, or other round objects, for tracing

→ Pencil

→ Watercolor paint

→ Paintbrushes

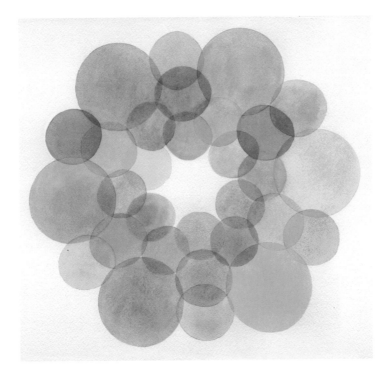

ONE OF THE MOST ENJOYABLE CHARACTERISTICS OF WATERCOLOR IS ITS TRANSPARENCY. It allows for the gradual building up of rich, vibrant hues. And blending different colors is possible simply by layering them. Each new layer adds a tinted lens to the colors below. In this exercise, the circles in a kaleidoscopic ring are each filled with transparent color, and the overlapping areas reveal a variety of color surprises. Have fun painting, overlapping the circles, and predicting which colors will pop up next.

Let's Go!

1. Use a piece of cardboard tube to trace a center circle and then make a ring of circles around it (fig. 1).

2. Add an outer ring of circles that overlaps the circles in the first row, centering each second row circle over two of the circles from the first row (fig. 2). The areas of overlap are where the blending will happen.

3. Paint each circle in the first row a different color and allow it to dry (fig. 3). Then paint the outer row of circles. Be mindful of color placement. The best blending and kaleidoscope effects will happen if you overlap complementary colors.

4. Trace more rows of overlapping circles using different sizes for variety (fig. 4). Keep adding circles until you fill the page.

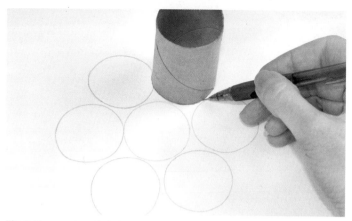

Fig. 1: *Trace a ring of circles.*

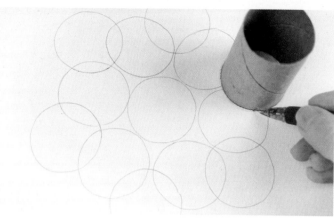

Fig. 2: *Trace a second row of overlapping circles.*

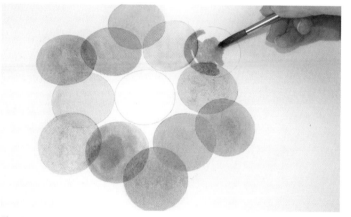

Fig. 3: *Paint the circles.*

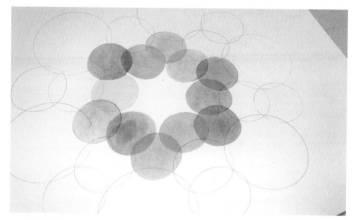

Fig. 4: *Add more rows.*

Inspiring Artist: Sarah Bonetti

This simple, but compelling, piece by Sarah Bonetti highlights the beautiful transparency of watercolor. Sarah is an illustrator and artist from Novara, Italy. She has worked in advertising and editorial illustration and as an animation background artist. She creates prints, original illustrations, sculpture, and paintings in a variety of different techniques and is inspired by myths, music, fairy tales, religious art, and classical poems. See more of her work at etsy.com/shop/LiquidoColorato.

Soft Bubble Hues by Sarah Bonetti

Little Hands

It can be a challenge for little ones to paint neat and tidy shapes with watercolor. Splashing is so much more fun, so why not embrace that? Let small children splash some watercolor on a page, allow it to dry, and then splash another layer of watercolor, creating a transparent layering effect.

Yellow is a great color to use last because it effects the most change to the most colors it touches.

COLLABORATIVE PAINTING

TWO PEOPLE, THREE COLORS, FOUR LAYERS—AND IT'S TWICE THE FUN WHEN YOU CREATE ART WITH A PARTNER. Challenge yourself and expand your comfort zone with this cool collaborative exercise that helps get you out of a color rut. Follow the simple, directed steps, trading the canvas with a friend, and enjoy the surprise that unfolds. The resulting painting will be a unique combination of the artistry of both participants and the exercise will stretch some underused creative muscles.

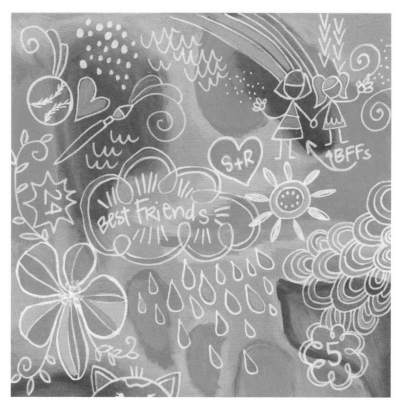

MATERIALS

→ Stretched canvas or canvas paper

→ Acrylic paint

→ Paintbrushes

→ Paper palette or coated paper plate

→ Paint pens, black or white

Let's Go!

1. Choose a three-color palette with your partner. The first partner paints a few shapes with the first color; the second partner then adds shapes with the second color for balance (fig. 1). One of the partners fills in the remaining white space with the third color. There is no need to be perfect.

2. Choose a companion color for each of the first three colors. Here, red is chosen for the maroon, hot pink for the coral, and sky blue for the gray-blue background (fig. 2). Add these companion colors around the edges of the large shapes to blend and soften them a bit. Have fun and just play with the paint. Both partners can work simultaneously, blending wet into wet paint, using quick, light strokes. These new tones will add depth and interest to the painting. Let dry.

3. Use a black or white paint pen or a fine paintbrush to add quirky, personalized doodles to the painting (fig. 3). Both partners will participate in this step. Work from all sides of the canvas, rotating it as you work. Add lucky numbers, initials, and favorite hobbies. Make the painting unique and special to you.

4. Add color to your doodles (fig. 4). Use thinned paint for transparent tints and full-strength paint for more opaque coverage. This is where your painting will really come to life.

Make sure you and your partner both sign your collaboration. Make a color copy of the painting so both friends will be able to take home this special artwork.

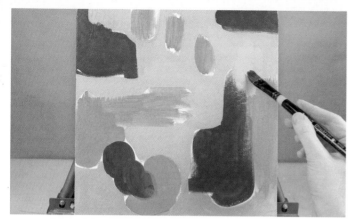

Fig. 1: *Paint chunks of color for the background.*

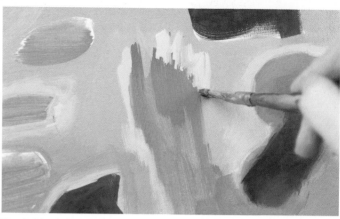

Fig. 2: *Blend the edges with additional colors.*

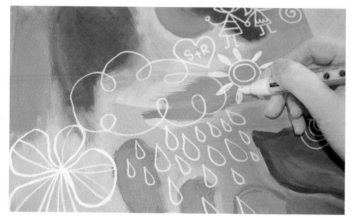

Fig. 3: *Add personalized doodles.*

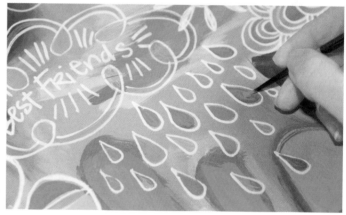

Fig. 4: *Color the doodles.*

Inspiring Artists: Lauren LaFond and Stephanie Corfee

This artwork is one of the collaborative works-by-mail that I did in 2014 with many kids across the country. My co-artist, Lauren, is just brimming with creativity and her color choices and bold doodles encouraged me to work in ways I normally wouldn't have. It was so much fun, and I think Lauren taught me a whole lot more than I taught her!

Kids Collaboration by Lauren LaFond and Stephanie Corfee

Little Hands

This is a wonderful project to do with a small child. Allow the child to take the lead and the adult can finesse the details. Let the child choose the colors and paint the first layer. The adult can work on the second step and smooth out the edges. Let the child draw adorable doodles and the adult can add color to make them stand out. This is a favorite project with my own kids, and the paintings we create are always a source of pride and bonding.

NINE PURPLE CIRCLES:
Dynamic Monochromatic Painting

MATERIALS

→ Acrylic paint in titanium white, magenta (or any non-orangey red), cerulean (or any bright blue), and black

→ Paper palette or coated paper plate

→ Palette knife for mixing (or feel free to use a paintbrush)

→ Small square canvas or square of heavyweight paper

→ Paintbrushes

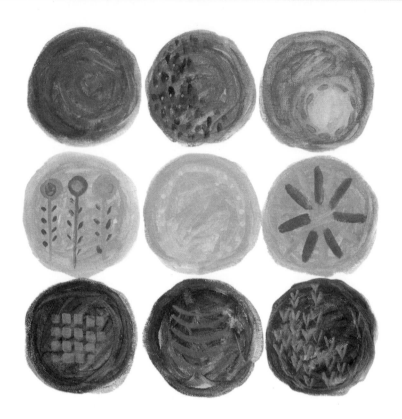

ONE OF THE BEST TOOLS IN YOUR ARTIST'S TOOLBOX IS COLOR. There are endless color variations just waiting to be explored. In this exercise, learn how to mix a handful of variations of the color purple; including hues, tints, and shades. You'll see that even a monochromatic painting can have a tremendous amount of variety and interest.

Let's Go!

1. Place a quarter-sized dollop of each paint color—white, magenta, blue, and black—along the top edge of the palette (fig. 1).

2. Make a second row of colors by mixing three different purples: (1) equal parts magenta + blue; (2) 2 parts magenta + 1 part blue; (3) 1 part magenta + 2 parts blue (fig. 2).

3. Make a third row of tints (lighter versions) of the three purple mixtures in row 2 by adding white to each. Take just a bit of each purple and then add a dollop of white.

4. Make a fourth row of shades (darker versions) of the three purple mixtures in row 2 by adding black to each. Take just a bit of each purple and then add a very small bit of black. Black is overpowering, so add just a speck at a time (fig. 3).

Fig. 1: *Place a dollop of each color along the edge of the palette.*

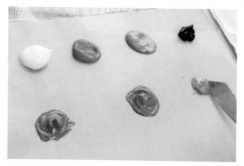

Fig. 2: *Mix three purples: one balanced, one warm, and one cool.*

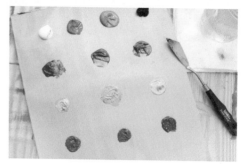

Fig. 3: *Mix a tint of each purple by adding white and then mix a shade of each by adding a touch of black.*

5. Paint a circle with each unique purple onto the canvas or paper. Keep them loose and sketchy (fig. 4). Let dry.

6. To finish, use the mixed purples on the palette to dab details onto each circle (fig. 5).

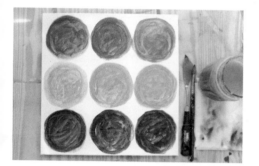

Fig. 4: *Use the nine purples to paint three rows of three circles each. Let dry.*

Fig. 5: *Add purple accents to each circle.*

Inspiring Artist: Wendy Brightbill

Wendy Brightbill is a mixed-media artist whose rich color palettes are wonderful examples of how layering different shades and tints of the same hue can make a major impact in a painting. "Painting is my joy, my lifeline, my therapy. I hope my art inspires joy in others." See more of Wendy's work at agirlandherbrush.com.

What Blooms in the Desert by Wendy Brightbill

Little Hands

Adapt this project for a small child by simplifying. Have her focus on the first set of paint mixtures. Place appropriate-size dollops of paint into clear plastic cups, and then give your child a paintbrush to stir each one. She'll see the different colors mixed right through the cup! Have her use the mixtures to paint an affordable, chunky, mini-canvas. Display the tiny masterpiece on your desk to boost her confidence through the roof!

WHITE BRIGHT:
Using White to Expand Your Palette

MATERIALS

→ Stretched canvas or heavyweight paper

→ Acrylic paint

→ Paintbrushes

→ Paper palette or coated paper plate

→ White pencil

PAINTING WITH ACRYLICS CAN BE AS SIMPLE AS SQUIRTING PAINT FROM THE TUBE AND SWIPING IT ONTO A CANVAS. Mixing colors, however, is quite an art, and learning how can broaden your color palette and make it more sophisticated. Using white is one of the simplest ways to do this. Add a little or add a lot. Endless tints will add interest, depth, and artistry to a basic, flat color palette. In this exercise, create a bold painting using a few colors right from the tube. Mix varying amounts of white into those colors to create tonal tints and details to finish.

Let's Go!

1. Paint a dark background color on a stretched canvas and allow it to dry (fig. 1).

2. Once dry, lightly sketch the arrows and feathers onto the background with a white pencil (fig. 2). Watercolor pencils are a great choice, if you have some, because the lines will dissolve and blend right into your wet acrylics when you begin to paint.

3. Paint the feathers and arrows using a variety of bold colors (fig. 3). Let dry.

4. Mix several tints using the bold colors plus white (fig. 4). Add a generous amount of white to get a very light version of the darker color. You want it to contrast with the darker color so it pops.

5. Use all of the tints to paint details onto the arrows and feathers (fig. 5). The lighter colors will jump forward in contrast to the darker ground. Let dry.

6. Finish the painting with accents in pure white to give it even more sparkle and brightness. White can be so amazing!

Fig. 1: *Paint the background with a dark color. Let dry.*

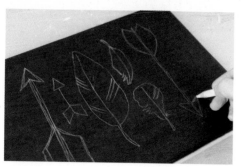

Fig. 2: *Sketch the shapes with a white pencil.*

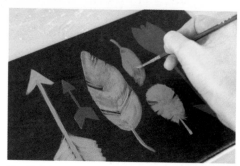

Fig. 3: *Paint the shapes with full strength paint. Let dry.*

Fig. 4: *Mix tints.*

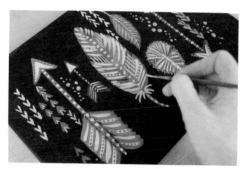

Fig. 5: *Paint with the tints. Let dry and then add white accents.*

Inspiring Artist: Rebecca Jones

Rebecca Jones, an English designer and illustrator living in Melbourne, Australia, shows what a gorgeous glow you can achieve with white paint. Rebecca has worked as a designer for many different companies worldwide and would draw all day long if she could. Rebecca is inspired by childhood memories, vintage children's books, and by nature and wildlife. Learn more at drawnbyrebeccajones.com.

Find Your Joy by Rebecca Jones

Little Hands

To adapt this project for little kids, go abstract. Paint the background as in step 1, above. But rather than mixing tints on the palette, have the kids use a flat brush and dip one side of their brush into a color, the other side into white, then scribble directly onto the canvas, blending the two colors as they go. Then choose a different color plus white to double-dip and blend next. By varying the amount of color versus white on the brush, a great number of tints are possible. The surprise comes as they scribble.

PHOTO INSPIRATION COLOR STUDY

SOME ARTISTS USE "SIGNATURE" COLOR COMBINATIONS OVER AND OVER AGAIN—AND THAT'S NOT A BAD THING. Using a distinct set of colors can be a great way to unify your aesthetic. But, to challenge yourself to try new color combinations and push outside your comfort zone, try using a photograph for color inspiration. In this exercise, make an eight-color swatch card inspired by a favorite photo. Use the swatch colors in a modern grid-style painting of expressive watercolor brushstrokes that tells a distinct color story.

MATERIALS

→ A photograph for inspiration

→ Hole punch (optional)

→ Watercolor paint

→ Paintbrush

→ Palette or coated paper plate

→ Watercolor paper

→ Ruler

→ Pencil

Let's Go!

1. Choose a favorite photograph with a variety of colors (fig. 1). Or take a photograph of favorite objects to use as your inspiration.

2. Choose eight specific colors to pull from the photograph (fig. 2). You can circle areas of the photograph. Or punch random holes in a card the same size as your photograph, laying the card over the photograph, and see what colors show through the holes. You have an instant swatch selector!

3. Mix your selected colors and paint a swatch of each color to serve as your guide (fig. 3). Just do your best; the colors don't have to be exact.

4. Use a ruler to sketch a pencil grid on heavyweight white paper, as large or small as you like (fig. 4). Five rows with five boxes each is a nice size to use. These lines will be erased later, so use a very light touch.

5. Alternate colors from your palette randomly as you paint one expressive brushstroke or blob in the center of each square on the grid (fig. 5). Make one simple mark per square and don't labor over the shapes, trying to make them perfect. The personality of the painting comes from the selected colors and the look of the marks. Are they bold? Timid? Varied? Or similar? This painting says a lot about its creator.

Don't forget to erase your pencil lines at the end.

Fig. 1: *Choose a photograph with a strong color story.*

Fig. 2: *Isolate eight specific colors in the photograph.*

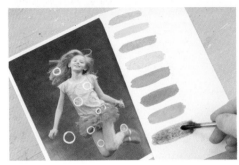

Fig. 3: *Mix the colors, creating a swatch palette.*

Fig. 4: *Sketch a light pencil grid.*

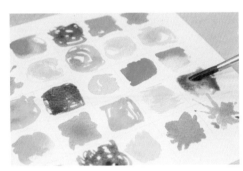

Fig. 5: *Make random brushstrokes on the grid alternating colors.*

Author's Inspiration

My inspiration for this abstract painting was a photograph I took in my studio when I was designing a cute little elephant figurine. It was accidentally beautiful. All the colorful paint drips, wood tones, lights and darks just spoke to me. The translated artwork pulls both a color story and a loose layout from the photograph. Keep inspirational photos pinned to a board on your wall or in a file in your computer. You never know when one of them will spark a new artwork.

Wake Up Sunshine!
by Stephanie Corfee

Practice, Practice!

—Choose a photograph with monochromatic color as your inspiration and explore how subtle color differences can convey a sense of calm and quiet.

—Choose a photograph with wild and contrasting colors as your inspiration and see how the extreme color differences give a feeling of energy and noise.

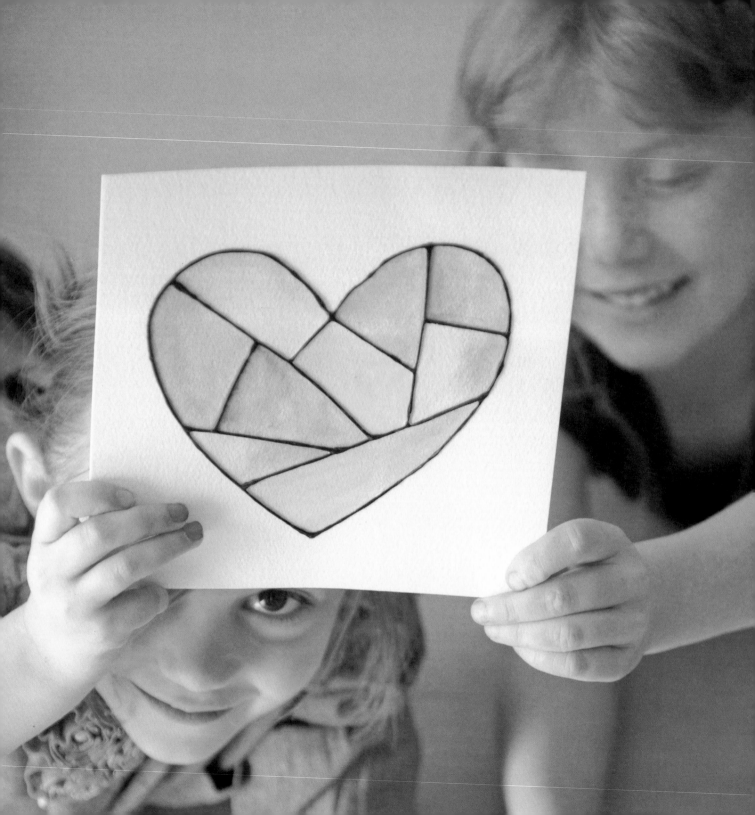

UNIT 05

EXPERIMENTATION STATION:
Mixed-Media Labs

PAINT IS A BEAUTIFUL THING. BUT IT'S NOT THE *ONLY* THING.

In this section, we will explore lots of interesting ways to take painting to a whole new level by incorporating new, and sometimes unusual, media. From adding tissue paper for texture and painting with paper towels, to learning simple batik techniques and incorporating photography into your work, the options might surprise you. Simply by getting to know these new materials and techniques, you will become a better artist. You will learn both the possibilities and the limits of each one, so you will be able to add them confidently into your work.

Learn a little about printmaking and using color washes on wood. Paint with coffee for a sepia tone effect and try soft pastels for a bit of "dry painting." You may not love every technique you try, but experimenting inevitably inspires growth and ideas. And that is what art and creative expression are all about.

Once you've tried the individual techniques, see how many you can incorporate into an over-the-top mixed-media artwork. Embrace the idea that a multitude of ideas, materials, tools, and textures can come together in one, unified masterpiece. Mixed media is so full of personality and deliberate choices. It can say a lot about the maker. What will yours say about you?

LAB 33

GLUE "BATIK" FABRIC PAINTING

MATERIALS

→ Blue gel glue

→ Child's cotton canvas apron

→ Acrylic craft paints

→ Paintbrushes

→ Container for thinning paint

BATIK IS A TRADITIONAL TECHNIQUE FOR MAKING TEXTILES IN WHICH A WAX RESIST IS USED TO CREATE A DESIGN ON FABRIC. The fabric is then dyed or painted, and the wax blocks the color from absorbing into the fabric in those areas. Once the fabric is dry, the wax is melted away to reveal the design. In this kid-friendly batik exercise, blue gel glue takes the place of the wax, and thinned acrylics are used in place of dye. It's always exciting to remove the resist at the end for the big design reveal!

Let's Go!

1. Use blue gel glue like puffy paint to create a design on a cotton canvas apron (fig. 1). Make abstract shapes or draw some artsy objects like brushes, pencils, and tubes of paint. Dry overnight.

2. Thin some acrylic craft paints with enough water to get a milk-like consistency. Two parts water to one part paint is about right. Then apply color all over the apron, painting right over the glue (fig. 2).

You can paint in a coloring book style, coloring in each object or doodle, or you can paint a wash of colors over the entire surface. Allow the paint to dry.

3. Soak the apron in warm water and rub the glue off with your fingers, and then dry it in the dryer (fig. 3).

An adult can lightly press the apron with an iron to smooth out any wrinkles.

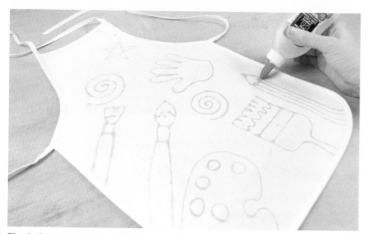

Fig. 1: *Create a design with blue gel glue.*

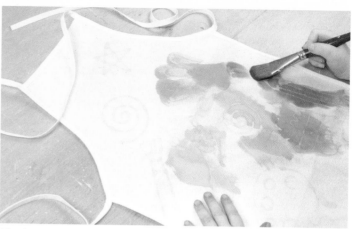

Fig. 2: *Apply thinned acrylic paint. Let dry.*

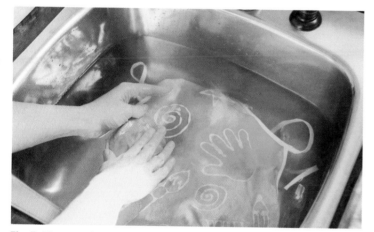

Fig. 3: *Rinse out the glue resist, then dry the apron in the dryer.*

Practice, Practice!

—Make a themed pillowcase using this batik technique, matching the color scheme to your room for a custom-design look.

—Try working two layers of batik designs. Complete all the steps above, and then add more glue designs in some areas and paint again. When you rinse the glue this time, you will see color from the first round of painting under the resist areas. This technique creates a more complex, layered effect.

Inspiring Artist: Pam Fish

Batik isn't just for fabrics! Check out this beautiful notecard by artist, Pam Fish. "I can't remember a time when I wasn't creating art! I try to incorporate themes of environmental friendliness into my artwork, using recycled materials in my weavings and natural patterns in my batiks." Pam is inspired by everything she sees, and draws most of her inspiration from neighborhood walks. Learn more at etsy.com/shop/fishwarp.

MultiSwirl by Pam Fish

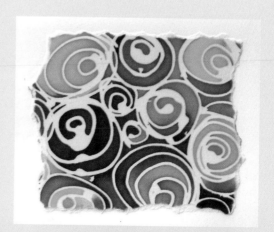

DAYDREAM PAINTING:
Working with Soft Pastels

MATERIALS

→ Dark colored paper

→ Scraps of paper to paint

→ Watercolor and craft paints

→ Paintbrushes

→ Pencil

→ Scissors

→ Glue stick or decoupage medium

→ Soft pastels

SOFT PASTELS ARE LIKE COLORED CHALK BUT THEY COME IN MUCH RICHER COLORS AND ARE EASIER TO BLEND. They allow an artist to "paint" with dry media and get stunning results. In this exercise, blended soft pastels are used along with painted-paper collage. Hazy pastel halos surround cut-paper images of favorite things in a chunky, simplistic, mixed-media collage.

Little Hands

Keep shapes simple for little kids. Have them make a page of painted paper stars or suns or even use large paper punches so they can make the shapes themselves. After the collages are finished, add a glow around each one with pastel. Have them blend the pastel with cotton swabs, not fingers, since the pastels are not safe to ingest. Wash hands thoroughly once the project is completed.

Let's Go!

1. Use any kind of paint you like to create fun, textured designs on scraps of paper (fig. 1). Use watercolor, acrylic, tempera, and craft paint and be sure to make a wide range of colors to choose from in your collage.

2. On a piece of colored cardstock, lightly sketch a layout for your "favorite things" with a pencil (fig. 2). Use simple shapes with few details; outlines work best for filling with pieces of collage paper.

3. Cut bits of the painted papers and begin to assemble your object collages, attaching the paper with a glue stick or decoupage medium (fig. 3). Overlap the papers and don't worry too much about being exact.

4. Once it's dry, add a soft pastel halo around each collaged item (fig. 4). Sketch the halos on with short, light strokes. Add more color close to the item and fade the amount of color as you work outward. To soften the halo, blend it with your finger, a cotton swab, or a tissue.

5. OPTIONAL: Finish with more soft pastel in the remaining areas if you like. This is the art of your daydreams!

Fig. 1: *Paint a variety of colorful designs on scraps of paper.*

Fig. 2: *Sketch a layout of your favorite things.*

Fig. 3: *Cut bits from the painted papers and assemble the collage. Let dry.*

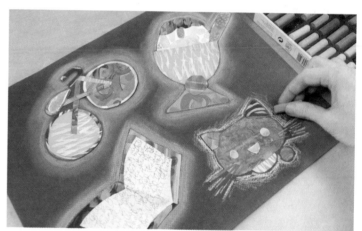
Fig. 4: *Apply pastels around the items and blend soft halos.*

Inspiring Artists: Mother and daughter, Victoria Johnson and Isadora Grasso (age 9)

These beautiful examples of soft and chalky pastels are by mother and daughter, Victoria Johnson, an English artist living in Rome, and her daughter Isadora, age nine. After twelve years working in New York as a fashion, textile, and paper product designer, Victoria moved to Italy and started her own collection of artwork. Her goal is to be commercial, original, and explorative, incorporating a variety of techniques into her work. See her work at victoriajohnsondesign.com.

Ship in Bottle 1 by Victoria Johnson and *Ship in Bottle 2* by Isadora Grasso

LAB 35 TISSUE TRANSPARENCY COLLAGE

MATERIALS

→ Heavyweight paper

→ Craft paint

→ Colored tissue paper

→ Paintbrushes

→ Paper palette or coated paper plate

→ Decoupage medium, gel medium, or thinned white glue

TISSUE PAPER ADDS A BEAUTIFUL LAYER OF COLOR AND TEXTURE TO YOUR ARTWORK. Its most exciting characteristic is its translucency; it allows light and color to pass through. Tissue paper can transform and deepen the beautiful color variations and brushwork of any background painting. For this project, bits of colored tissue paper are layered over a painted sky and branches to create a colorful leafy scene.

Let's Go!

1. Use three analogous colors (those next to each other on the color wheel) to paint a streaky sky (fig. 1). Pick up a different color each time you go back to your palette. Blot a little before painting for a dry brush effect that leaves the white of the paper showing. Allow the sky to dry and then paint a branch in a darker color in the middle of the paper.

2. Tear or cut up tissue paper in assorted colors (fig. 2). There is no need to make perfect leaf shapes; torn shapes or wonky cut shapes will work beautifully.

3. Apply tissue-paper leaves using a clear-drying adhesive like gel medium, thinned white glue, or decoupage medium (fig. 3). Layer the leaves until you are happy with the result. Notice how the painted background is still visible through the tissue and how the painted colors blend with the tissue colors. Let dry.

4. Use a fine paintbrush to create small designs on some of the leaves for another layer of detail on the finished art (fig. 4).

Fig. 1: *Paint the sky and a branch shape.*

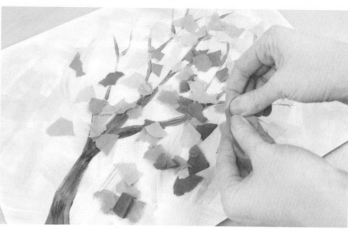

Fig. 2: *Tear the tissue paper into small pieces.*

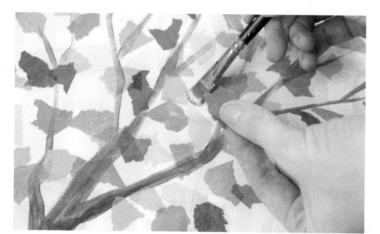

Fig. 3: *Apply the tissue with gel medium. Let dry.*

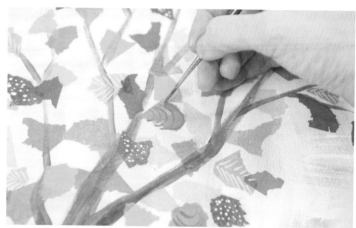

Fig. 4: *Add painted details.*

Inspiring Artist: Tracey English

The talented Tracey English shows her mastery of painted-paper and tissue collage in this design. Tracey first colors her tissue paper with either acrylic paint or ink and adds textures, marks, and squiggles to make it more interesting. She then cuts the tissue paper, glues it on, and adds details with paint and pen. Learn more at tracey-english.blogspot.co.uk.

House on the Hill by Tracey English

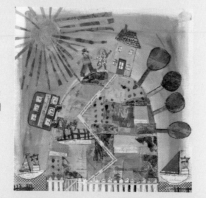

Practice, Practice!

—Try layering painted shapes and tissue shapes. Overlap them to see what interesting layered color combinations you can make.

—Use tissue as a middle layer of a painting: paint the background, add tissue, and then paint again. Play with colors to see what different combinations you can create.

KITCHEN SINK PAINTING:
Extreme Mixed Media

→ Stretched canvas

→ Acrylic paint

→ Paintbrushes

→ Paper palette or coated paper plate

→ White glue

→ Gel medium or decoupage medium

→ Hot glue gun (optional)

→ Assorted mixed-media items: lace, beads, string, dried flowers, card stock, tissue paper, tags, or ribbons.

→ Decorating tools such as paint pens, stamps, puffy paint, and bubble wrap

Practice, Practice!

—Build a three-dimensional sculptural piece like the one made by our featured artist. Use painted paper, wire, glue, and add other found objects.

—Create a "Year in Review" collage keepsake with mementos and trinkets, ticket stubs and photographs from your school year.

MIXED-MEDIA ARTWORK CAN BE SIMPLE AND SWEET, USING TWO OR THREE TECHNIQUES. But it can also be a wild and explosive mix using all kinds of tools, supplies, found objects, and textures. You can use whatever feels right to your artistic vision. In this lesson, explore *excess*. Make a collage-and-paint extravaganza using lace, fabric, string, tissue, dried flowers, paper punches, stamps, beads, paint pens, glitter, and more in an over-the-top composition that artfully combines all the scraps from your past projects.

Let's Go!

Gather a range of materials to use in your collage before you start. Choose objects that are lightweight enough to attach to the canvas with white glue or gel medium such as tags, bits of fabric or lace, glitter, bottle caps, painted papers leftover from other projects, photographs, artificial flowers, sequins, beads, and fortunes from fortune cookies. You are limited only by your imagination.

1. Create the base layer using any items that will lay flat (fig. 1). Paint the canvas with craft paint, adding texture and pattern, if you like. Add flat media like papers, fabric, and tissue. Here, a loose grid is painted onto the canvas to create a template for the placement of the collage items.

2. Build the next layer of your mixed-media art with textural items that will add a bit of height such as lace, seed beads, and foam shapes covered with tissue and attach them with white glue (fig. 2). Allow the glue to dry before working on the next layer.

3. Create some contrast with touches of black (fig. 3). Try puffy paint dots, black paint pen, or ink stamps to add design elements that will draw attention and give some balance to all the colors in your piece.

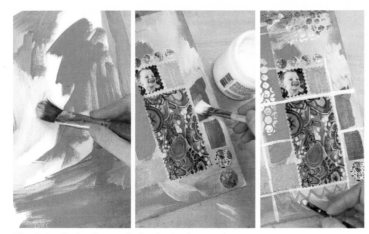

Fig. 1: *Apply the flat media for the background.*

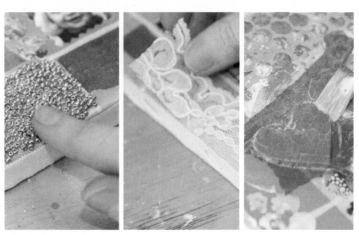

Fig. 2: *Apply textural media.*

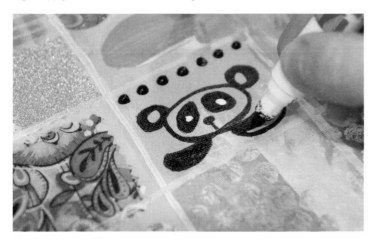

Fig. 3: *Add some black.*

Fig. 4: *Add some three-dimensional items.*

4. Finish the piece by adding some three-dimensional objects such as folded paper shapes, dried flowers, and bows (fig. 4). Use white glue or have an adult help by adhering the objects firmly with hot glue.

These steps are just a basic guideline for building up layers. Use your imagination, be creative, and think outside the box to make something truly unique!

Inspiring Artist:
Vanessa "Kiki" Johanning

Vanessa "Kiki" Johanning is a nationally acclaimed mixed-media artist who tries to embellish every moment of her life. She collects crocheted lace, rhinestones, smiles, and experiences! She is a trend spotter, designer, a lover of color, and is represented by several galleries in the Midwest. See her work at vanessajohanning.com.

Silly Mixed Up Wire Bird by Vanessa "Kiki" Johanning

WOOD PLANK ZEBRA:
Staining Wood with Paint

MATERIALS

→ Craft wood

→ Black paint pen

→ Craft paint

→ Paintbrushes

→ Small paper cups

→ Clear paste wax (optional)

→ Rags (optional)

Practice, Practice!

—Make a family name wall plaque by painting the letters of your last name with colorful washes. For an elegant look, add color or a traditional brown stain to the background.

—Make art for a beach house using the color wash technique on driftwood. Paint outlines of seashells or surfboards and fill with transparent color. Distress it to give it a more rugged appearance.

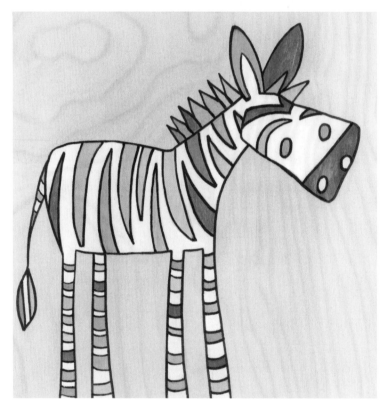

PAINT IS SO TRANSFORMATIVE. IT CAN CHANGE PRACTICALLY ANYTHING! In this lesson, craft paint is thinned with water for use as a tint or stain on porous wood (wood that has not been sealed). It's a beautiful technique and a great way to show kids that paint works on more than paper. Paint a very simple zebra and then give him whitewash and color wash treatments to create vivid stripes that allow the beauty of the wood grain to shine through.

Let's Go!

1. Use a liner brush or a paint pen to make a simple zebra shape with stripes (fig. 1).

2. In a small paper cup, thin some white paint with water to create a milky wash. If you are using craft paint, use about two parts water to one part paint. Thicker acrylics may require more water. Paint the zebra's body (fig. 2). The whitewash will absorb into the wood leaving just a haze of color.

3. Choose a few colors of paint and thin them the same way as you did the white paint. Paint the stripes, mane, eyes, and nose (fig. 3). Notice how the grain and texture of the wood is still visible once the color wash is absorbed? The thinned paint is similar to a stain.

4. OPTIONAL: Once the paint is dry, rub on a thin layer of clear paste wax (fig. 4). Then buff with a clean rag for a perfect, finished sheen.

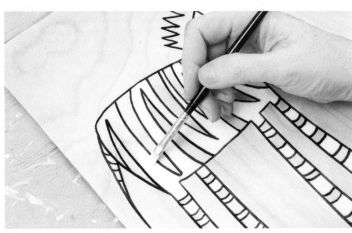

Fig. 1: *Draw the outline of the zebra.*

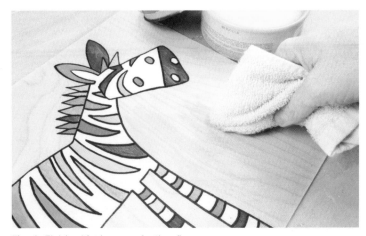

Fig. 2: *Whitewash the body.*

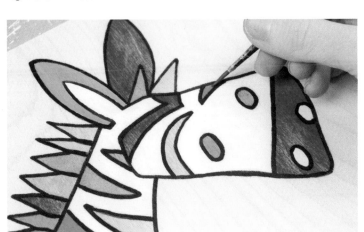

Fig. 3: *Color wash the stripes and details. Let dry.*

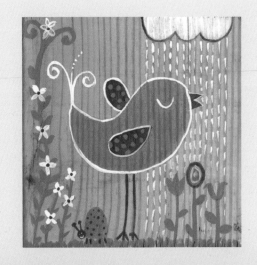

Fig. 4: *Finish with clear wax (optional).*

Inspiring Artist: Katie Doucette

This adorable bird painted on wood is by Katie Doucette, a mom, wife, and artist who works from her home in Saugatuck, Michigan. She designs and manufactures customized artwork for her own shop as well as gift shops around the Midwest. Her slightly vintage style has a hint of whimsy and inspiration. See more of her work at polkadotmitten.com.

Spring Showers by Katie Doucette

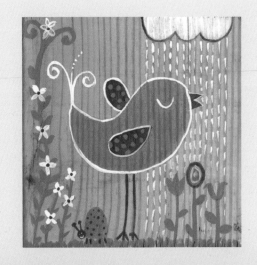

COFFEE-SAURUS:
Sepia Tonal Painting with Coffee

EXPERIMENTING IS A FUNDAMENTAL PART OF CREATING ART. Try new things. Think outside the box. See what you can make with limited materials. In this exercise, strong coffee (or tea) takes the place of watercolor paint and produces warm sepia tones that make the art look old. Make a dinosaur silhouette painting with an aged look using coffee staining, spatters, and taped resist areas. It's an aged look that's made today.

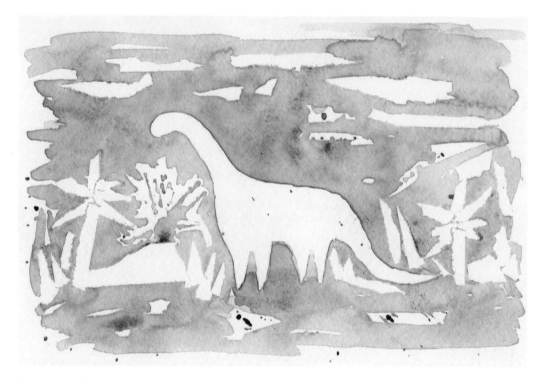

MATERIALS

→ Watercolor paper

→ Pencil

→ Blue painter's tape

→ Strong black coffee, cooled

→ Paintbrush

Let's Go!

1. Lightly sketch a dinosaur outline onto watercolor paper with a pencil (fig. 1). Use a reference photo or your imagination to design your dinosaur or trace an outline using a light box, if you like. Tear bits of blue painter's tape to build palm trees, clouds, and volcanoes around your dinosaur.

2. Dampen the area around the dinosaur. Paint with strong black coffee all around the edge of the pencil drawing (fig. 2). Fade the color as you work outward from the silhouette. If the color is very weak, you may need a more concentrated cup of coffee.

3. Add some spatters or blown-straw marks around the landscape and the dinosaur (fig. 3). A volcano is the perfect spot for some explosive marks and spatters.

4. Once the paper is dry, gently peel away the painter's tape to reveal your finished coffee painting (fig. 4).

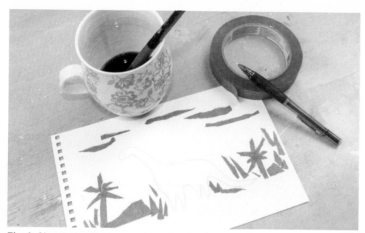

Fig. 1: *Sketch the dinosaur and create a landscape using tape.*

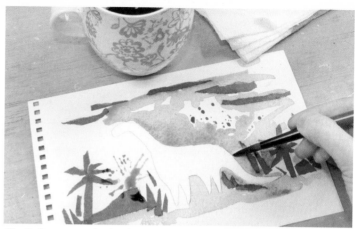

Fig. 2: *Dampen and paint the negative area with the coffee.*

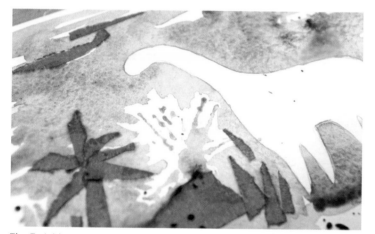

Fig. 3: *Add some spatters and flecks.*

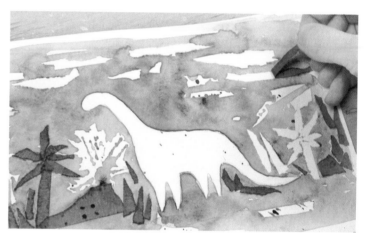

Fig. 4: *Carefully remove the tape.*

Inspiring Artist: Zach Franzen

Some folks prefer coffee, but Zach Franzen likes tea, as shown in this charming artwork painted with brewed tea. During the day, Zach illustrates textbooks; at night he illustrates middle-grade fiction. Zach lives in Greenville, South Carolina, with his wife and daughter. You can check out his work at atozach.com.

Tea Time: Elephant and Mouse by Zach Franzen

Little Hands

Consider making a coffee-saurus fossil painting with small children. Draw a simple bone shape on wide painter's tape. Cut out the shape and stick it in the center of your paper. Then let little ones spread the coffee or tea all over the page. They can drip, spatter, or use a straw to blow streaks of the liquid. Once the paper is dry, peel away the painter's tape to uncover your dinosaur bone. What a discovery!

ALTERED PHOTOS:
Love You Bunches Painting

MATERIALS

→ Stretched canvas

→ Acrylic paint

→ Paintbrushes

→ Paper palette or coated paper plate

→ Photograph printed on white copy paper

→ Gel medium, thinned white glue, or decoupage medium

→ Bubble wrap

PHOTOGRAPHS ADD A GREAT PERSONAL TOUCH TO MIXED-MEDIA PROJECTS. They're even more fun when they are embellished with doodles and paint and other materials. In this lesson, create a colorful work of art that uses a photograph printout as the base. Use paint pens, craft paints, and other media to create a special piece for a mom, grandmother, or other loved one.

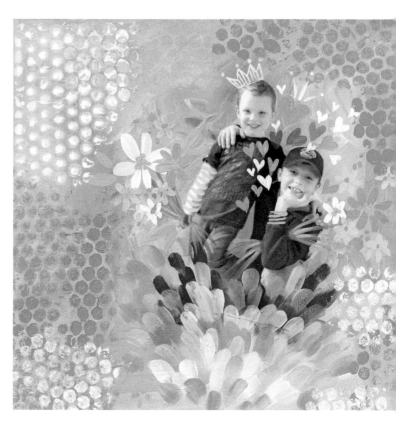

Practice, Practice!

—Make a family photograph collage with specific doodles, colors, and embellishments on each person's image that shows their personality.

—Make a photograph journal page that features you. Embellish it artistically to show what's in your heart and mind—to show you as you see yourself.

Let's Go!

1. Paint some background color onto a stretched canvas (fig. 1). It can be messy. Use colors the recipient will like. Let dry. Then glue down a trimmed printout of your photograph. The print will work best if it is on thin paper like copy paper. Use decoupage medium, thinned white glue, or gel medium to adhere the print and then coat the surface of the image once it is adhered.

2. Paint around the edges of the image to fully incorporate it into the background (fig. 2). This will also anchor it so that it does not appear to be floating on the surface.

3. Embellish and decorate the image (fig. 3). Have some fun by drawing on a mustache, funny hats or crowns, or rosy cheeks. Add designs on the clothing, word bubbles, or silly props. For a bit of whimsy, paint items into the hands of the people in the photograph, such as the bouquets shown here.

4. Add some texture (fig. 4) by stamping with bubble wrap or brushstrokes to add another layer of interest to the artwork. Vary the colors of these final embellishments to create some balance.

Fig. 1: *Paint the background, let dry, and glue the photograph on top.*

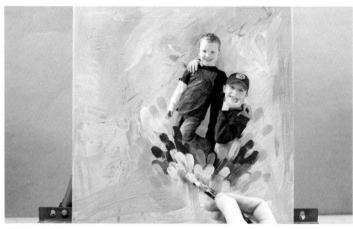

Fig. 2: *Paint around the photograph, overlapping the image, to incorporate it into the painting.*

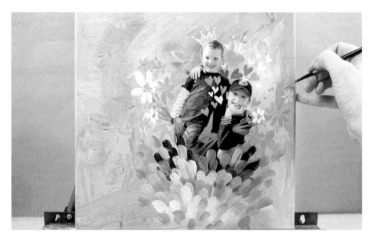

Fig. 3: *Embellish the photograph.*

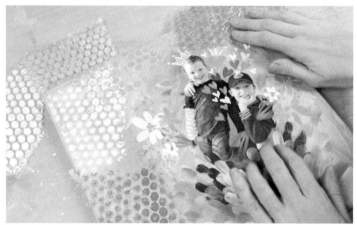

Fig. 4: *Add a final layer of paint and texture.*

Inspiring Artist: Jenny Doh

Among her many creative endeavors, Jenny Doh alters photographs with style and quirk. Born in Seoul, South Korea, Jenny moved to the United States in 1974. She is the author and packager of a number of art and crafting books. Her latest illustrated children's book is *Fangs and Flaws: FangGrrr Adventures*. Jenny runs Studio Crescendoh, where she teaches painting and fiber arts. She lives with her family in Santa Ana, California. See her work at blog.crescendoh.com.

Ride by Jenny Doh

DIMENSIONAL OUTLINES:
Stained Glass Watercolor

MATERIALS

→ Watercolor paper

→ Pencil

→ Dimensional paint in black

→ Watercolor paints in various colors

→ Small paintbrush

Little Hands

This project can be great for smaller children. Watercolors make for easy cleanup and the dimensional paint outlines keep colors neatly in place. Let your child choose a simple design like a heart or star and simply create the outline for him—he can handle the paint. If your child is too small to handle even a watercolor pan set, there's still a way: Create a very simple, three-section shape with dimensional paint, offer three pairs of analogous watercolor *pencils*; one pair to color each section, and then blend together with a damp brush.

WATERCOLOR BEHAVES LIKE NO OTHER MEDIUM. With just a bit of extra water, vivid, transparent colors mingle and swirl together beautifully to yield unique results every time. Use black *dimensional* paint to create a simple stained glass–inspired design in this fun exercise. Learn about analogous color blending along the way.

Let's Go!

1. Lightly sketch a simple stained-glass design on the paper. Break up large areas into smaller segments to get a stained-glass look (fig. 1).

2. Trace over the pencil lines using the dimensional paint, making sure to pull the tip along each line rather than push it. Practice a few lines on scrap paper first to get a feeling for how the paint flows from the tube (fig. 2).

3. Allow the dimensional paint to dry overnight.

4. Wet the paper in a section of the painted design. Add a color to one side of that section (fig. 3).

5. Choose an analogous color of paint. Add that color to the opposite side of the section right up until the two colors touch (fig. 4).

6. Rinse the brush and use it to gently blend the two colors at the center (fig. 5).

Repeat these steps in every section of the design. Have fun choosing color combinations and refer to the color wheel shown on the following page if you need guidance with analogous color combinations.

Fig. 1: *Draw a design in pencil first to use as a guide.*

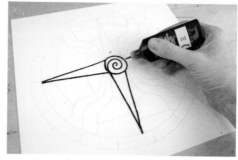

Fig. 2: *Apply dimensional paint over the sketch. Let dry.*

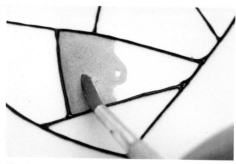

Fig. 3: *Dampen one area with water, and then add color.*

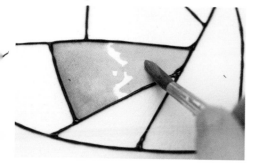

Fig. 4: *Add a second, analogous color. Let the water do most of the work.*

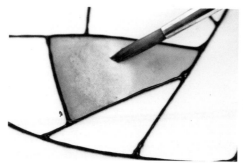

Fig. 5: *Use a clean, damp brush to blur the line between the colors.*

Author's Inspiration

Watercolor is one of my favorite mediums. The mingling of colors in a puddle of water is magic to me. I created this piece with mosaic and stained glass in mind. I've also used salt textures and layering to achieve a dynamic effect in each section. In fact, my 3-year-old collaborator loves to sit beside me and sprinkle salt as I paint. Give it a try!

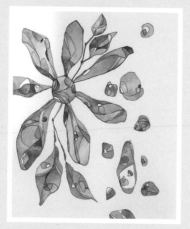

Shattered Flower by Stephanie Corfee

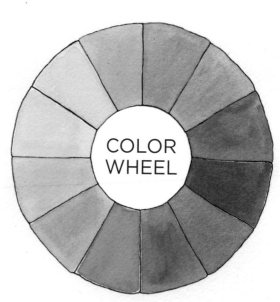

On the color wheel, analogous colors lie right next to one another, or one step away from one another.

LIGHTNING STORM:
Decoupage & Rubbing Technique

MATERIALS

→ Tissue paper

→ Sturdy cardboard

→ Decoupage medium

→ Craft paint

→ Paintbrushes

→ Paper palette or coated paper plates

→ Soft pastels

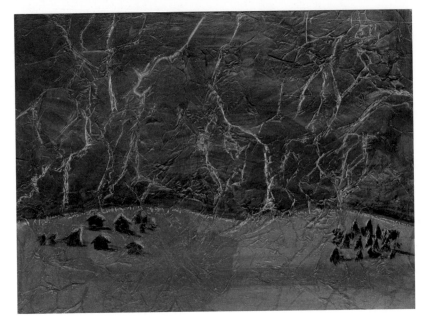

LAYERING AND EXPERIMENTING ARE SOME OF THE MOST REWARDING ASPECTS OF WORKING WITH PAINT. Building up colors to create a sense of dimension can feel a bit like magic. And some of the most incredible effects can be achieved with simple supplies. In this exercise, combine decoupage and a pastel rubbing technique to create a stormy night sky. Encourage lots of wrinkles as you decoupage tissue paper onto heavy cardboard. Then rub bright pastels across the surface to create vibrant flashes of lightning across a darkened landscape.

Little Hands

Oh, the fun little ones will have crumpling colorful sheets of tissue! Allow them to crinkle colored tissue while the adult spreads an even layer of decoupage medium on the cardboard. Children can smooth each section a bit, then let the adult finish adhering it while the child crinkles the next color of tissue. Skip making a landscape, and just work on layering the colored papers. Then show the kids how to hold chalk or a pastel on its side to do a rubbing. They will want to coat every crinkle.

Let's Go!

1. Crinkle several sheets of tissue paper in a variety of dark shades. Add decoupage medium to the canvas board and encourage the wrinkles to remain as you adhere the tissue to the cardboard (fig. 1). Continue until the board is completely covered. Then coat the entire surface with more decoupage medium and allow it to dry.

2. Use a dark blue or purple acrylic paint to make a wavy line separating land and sky (fig. 2). Paint above the line so the sky is very dark. Let dry.

3. Pick out some pronounced wrinkles in the tissue and lightly rub bright pastels along the raised creases to make bolts of lightning that end at the horizon (fig. 3).

4. Use black paint to add some houses, trees, and shrubs across the landscape (fig. 4). If you like, add some bright pastel highlights to the houses and trees so they look like the light is falling on them.

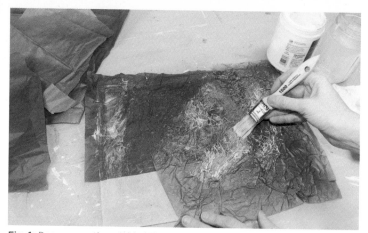

Fig. 1: *Decoupage the crinkled tissue. Let dry.*

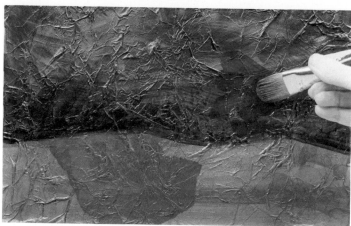

Fig. 2: *Paint in the sky. Let dry.*

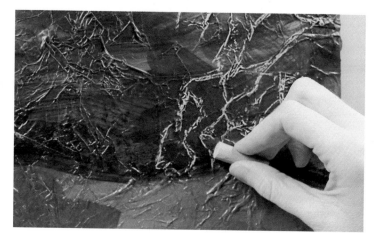

Fig. 3: *Rub on pastel for the lightning.*

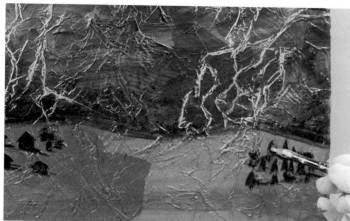

Fig. 4: *Add trees and buildings.*

Inspiring Artist: Christine Mercier

This stunning artwork by Christine Mercier gets its texture from silk fabric adhered to the canvas prior to painting. Working as a fashion designer for many years, Christine later expanded her practice to include silk painting and abstract acrylics. "Abstract art allows me to express my emotions spontaneously, without filter," says this Canadian artist. Fabric is the link between her practices and has naturally integrated itself into her art. See her work at etsy.com/shop/artcm.

Untitled Mixed Media 2014 by Christine Mercier

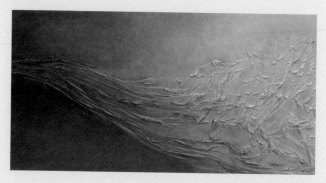

ON A ROLL:
Continuous Surface Pattern

MATERIALS

→ Hand-held adhesive lint roller

→ Adhesive-back foam sheets or foam shapes

→ Scissors

→ Acrylic paint

→ Paper palette or coated paper plate

→ Roll of heavyweight paper

CREATING PRINTED PAPERS IS AN EXCITING ACTIVITY FOR KIDS AND THE RESULTS CAN BE VERY USEFUL. Make the process fun and the application efficient by building stamp designs directly onto sticky lint rollers. Printing large sheets of paper goes a whole lot faster and kids have a blast rolling out their designs.

In this exercise, create a simple, graphic printing tool with a tribal-inspired look. Make papers that can be used as stylish book covers and bold gift wrap.

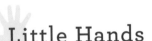

Little Hands

For younger kids precut foam shapes are great for this project. Encourage them to create a random pattern of foam shapes on the rollers with only a little space between the pieces to help avoid paint buildup in those void areas. A random pattern of shapes also makes it less important to roll straight lines of roller prints on the page. Multicolor overlaps will camouflage a multitude of mistakes, too. So, plan to use three or more colors with lots of layering.

Let's Go!

1. Cut shapes from a sheet of self-stick craft foam (fig. 1). Cut V-shapes by snipping at an angle in toward the center of a strip of foam. Then switch to the other side and snip a second row. Cut out various sizes of triangles.

2. Remove the adhesive backing from the foam pieces and attach them to the lint roller in rows (fig. 2). The sticky surface of the lint roller, plus adhesive on the foam, will create a firm attachment.

3. Spread a thin layer of black acrylic paint onto a paper palette. Load the paint onto the roller so that all the foam shapes are covered in black, but not dripping with paint. To print, roll the tool across a large sheet of drawing paper (fig. 3). Repeat as necessary to fill the surface.

4. OPTIONAL: If you like, grab a brush and add a few accents with paint for a boost of color. Then wrap gifts or cover books with your patterned paper!

Fig. 1: *Cut shapes from the foam.*

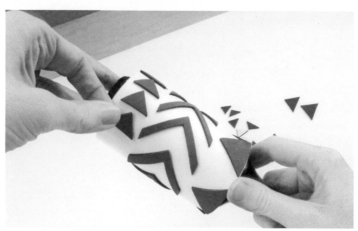

Fig. 2: *Adhere the foam shapes to the lint roller in a pattern.*

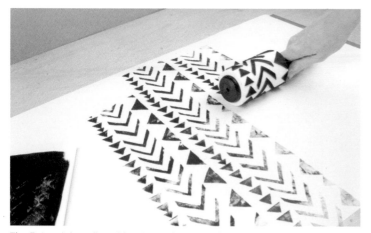

Fig. 3: *Load the roller with paint and print on the paper.*

Inspiring Artist: Toni Thomas

This adorable hand-printed wrapping paper is by Toni Thomas. Toni started her company, Toastcrafts, at home when her daughters started school. "I have always enjoyed making cards and other crafty bits," says the British designer. Toni focuses mainly on lino printing (using linoleum as the printing tool) because she finds it a really fun medium to use, and she can make one lino block and reprint using many different colors. See more of her creativity at etsy.com/shop/toastcrafts.

Hand-printed robin wrapping paper by Toni Thomas

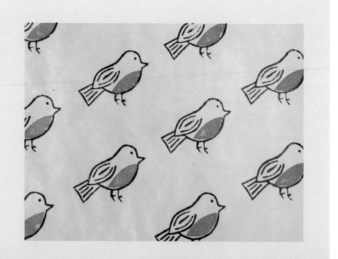

PAPER TOWEL TRANSFER METHOD:
Moths 'Round the Moon

MATERIALS

→ Watercolor paper

→ Watercolor paint

→ Paper towel

→ Paintbrushes

→ White craft paint for stars

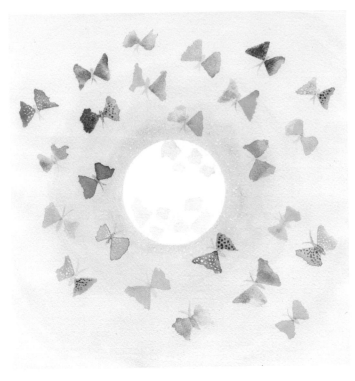

TRYING NEW TECHNIQUES FOR APPLYING PAINT IS ALWAYS INTERESTING, ESPECIALLY WHEN THE SUPPLIES ARE SO BASIC AND THE RESULTS ARE SO MUCH FUN. In this project, turn tiny shreds of paper towel into an eclipse of colorful moths circling the moon using just a few drops of watercolor. The absorbent paper towels make perfectly shaped moth wings and a textured surface on the moon. It's simple and sweet.

Let's Go!

1. Trace a circle onto the center of a piece of watercolor paper. Use diluted blue watercolor to build a ring around the circle, having it fade lighter and lighter as you move outward (fig. 1).

2. Tear a few random shapes of paper towel for the moon. Then, cut a stack of paper towel squares that measure about 1" x 1" [2.5 x 2.5 cm] each. Tear off the corners of the square to create triangles that each have one perfect corner and one rough edge (fig. 2). These triangles will be the moth's wings. Arrange the triangles on the page, around the moon, as shown.

3. Mix a generous amount of water to the pigment in your watercolors. Start by adding large drops of vivid watercolor to the brush. Touch the loaded brush down onto the paper towel. Do not swipe. You want to saturate the shred of paper towel so that it settles and makes good contact with the paper underneath (fig. 3). This allows the watercolor to transfer to the paper.

4. Wait about 10 to 15 minutes and, then carefully remove the paper towel bits (fig. 4). If you notice any areas where paint didn't transfer, you can fill it in with a small paintbrush.

5. Use a small paintbrush to add bodies and antennae to the moths (fig. 5). Add dots to the moth's wings for a bit of pattern and dots to the night sky to indicate stars.

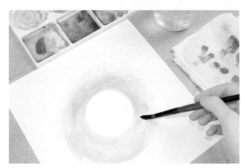

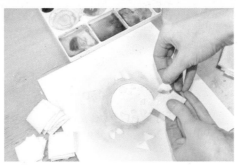

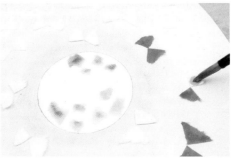

Fig. 1: *Trace a circle and paint a halo of blue watercolor around it.*

Fig. 2: *Cut and tear wing shapes from the paper towel and arrange them on the paper.*

Fig. 3: *Drip watercolor onto each piece of paper towel.*

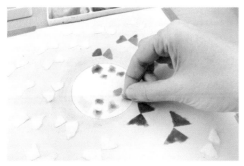

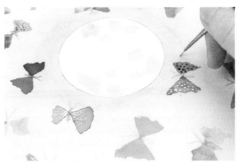

Fig. 4: *Remove the soaked paper towel pieces.*

Fig. 5: *Paint details with a small brush.*

Inspiring Artist: Cynthia Shaffer

Paper towels stained with paint turn to art in the hands of artist Cynthia Shaffer. Cynthia is a mixed-media artist, a creative sewer, and a photographer whose love of art can be traced back to childhood. She is the author of five sewing and craft books and has been featured in numerous books and magazines. Cynthia lives with her husband Scott in Southern California. Learn more at cynthiashaffer.com.

Inspire notecard by Cynthia Shaffer

Little Hands

Small children will enjoy the tearing and dripping most in this exercise, so allow them to be expressive and abstract rather than try to form moths. Encourage them to tear up the paper towel into larger chunks, if they wish, and to layer the pieces. When it comes time to paint the pieces with watercolor, simply guide them to move from piece to piece rather than oversaturating any one area. The resulting abstract forms will look like modern art.

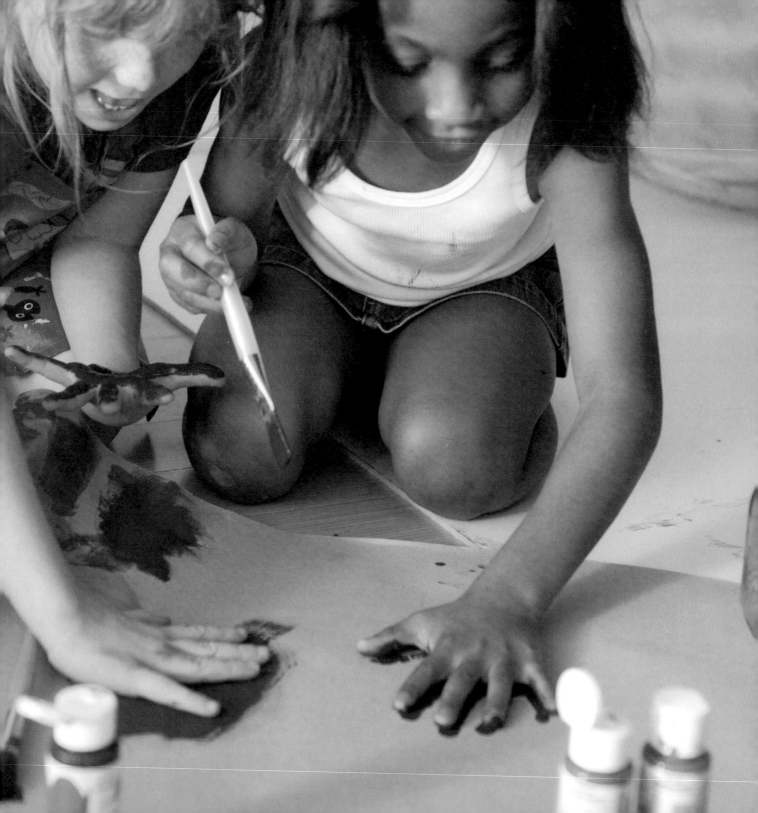

UNIT 06

EXPRESS YOURSELF:
Inspirational Labs

A LOT OF ART INSTRUCTION DEALS WITH THE PRACTICAL ASPECTS OF PUTTING PAINT TO CANVAS AND PENCIL TO PAPER. We learn about techniques and tools, best practices, and lots of ways to use our beloved stash of craft supplies to create something beautiful. But in an art book, especially one for kids, it's equally important to address the intangibles. WHY do we create? HOW do we see our world? WHAT do we feel when we are making artwork? And does any of this affect the final outcome?

I know it does.

So this section of the book focuses on self-expression and the many ways that we can encourage kids to tap into their uniqueness. The projects here have steps listed; you have to start somewhere. But these steps are meant to be loose guides rather than strict directives. Similarly, the final artwork shown for each Lab should be viewed more as inspiration than as a perfect specimen to be studied and duplicated.

So please, take creative license! Paint your self-portrait sideways. Ditch the brushes and finger paint to your favorite song. Mix and match ideas and create art that feels like *you*. Create art that your friends would recognize immediately as yours. Your artistic voice is such a gift. It does no good to ignore it and try to copy what someone else is doing. The world wants to see your quirks and individuality, so let them show!

LAB 44

THAT'S SO YOU!
Stylized Self-Portraits

MATERIALS

→ Stretched canvas

→ Acrylic paints

→ Paintbrushes

→ Paper palette or coated paper plate

→ Black paint pen or liner brush

→ Mirror

Little Hands

To me, self-portraits made by small children are quite possibly the best art form there is. Little kids can follow the same steps as big kids; just expect that their work will be a lot more wobbly and disproportionate. I wouldn't change any of the directions in this project; I would only suggest that you give little ones the freedom to paint themselves however they like with very little guidance or correction. In fact, make it an annual tradition to paint these self-portraits, and in time, the early images will become more and more cherished.

ARTISTS HAVE BEEN PAINTING SELF-PORTRAITS FOR CENTURIES. Some are realistic, and others are more stylized—meaning they show the creative essence of the artist filtered through their particular style of painting. For this project, create a whimsical self-portrait that is more interpretive than literal. Simplify each facial feature to its basic shape. Use favorite colors and decorative details. Paint yourself imaginatively, take creative license, and alter or enhance parts of the portrait, as you like. You are the artist, and you can add whatever visual touches you like to create your portrait.

Let's Go!

1. Begin by looking in a mirror while you work. Paint a simplified outline of your face shape (fig. 1). Is it oval, round, square, or heart-shaped? Add a neck and shoulders too. Then paint the face in two colors, one color on the left and another on the right. Don't forget to paint the neck, too.

2. Look in the mirror again. Paint simple outlines of your facial features (fig. 2). Are your eyes mostly round, or angled? Is your nose like a button, or a triangle? What shape is your mouth? Add simple lines to indicate your hairline and hair shape.

3. Now, play with color. Paint each of your features and the background of the painting (fig. 3). Use fun colors. They don't have to be realistic. What feels like you?

4. Once it's dry, use a fine brush and black paint to add some whimsical touches (fig. 4), anything you love. Add symbols to indicate your hobbies and interests. Add stars or flowers. Anything goes!

5. Finish by adding color to these personal doodles.

Fig. 1: *Outline a basic face and neck shape and add color. Let dry.*

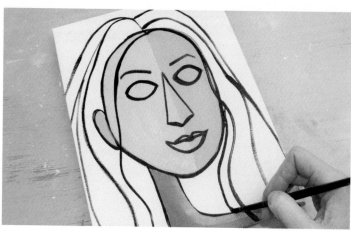

Fig. 2: *Add facial features and hair.*

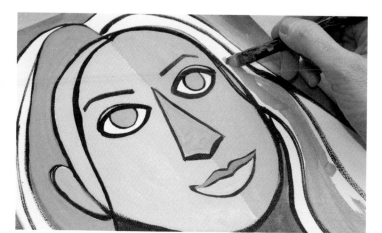

Fig. 3: *Paint the features and background color. Let dry.*

Fig. 4: *Add decorative details.*

Inspiring Artist: Madeleine de Kemp

Whimsical faces filled with personality and charm are a specialty of the talented Madeleine de Kemp. Madeleine is a Dutch mixed-media artist and art journaler who also loves to make doodle drawings full of color and whimsy. She shares her work with the world on her blog at makeartbehappy.blogspot.com.

Little Mermaid and Friends
by Madeleine de Kemp

FINGER-PAINTING POWER

→ Paper palette or coated paper plate

→ Heavyweight white paper

→ Nontoxic acrylic craft paint

Practice, Practice!

—Try applying a larger amount of paint to a paper and then using your fingers to scrape away fun textures instead of adding them.

—Try creating a sense of vibrating movement by swiping tiny, wavy marks onto the page with all of your fingertips at a time. Layer in lots of fresh colors. Be sure to allow drying time between layers to avoid overmixing and muddy colors. By applying several parallel, curvy swooshes with every touch, you will create a sense of rhythm.

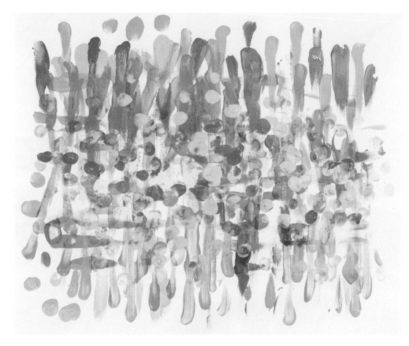

USE ALL TEN FINGERS TO PAINT! FINGER PAINTING IS A GREAT SENSORY EXPERIENCE AND FEELS VERY NATURAL. Especially good for kids who aren't comfortable working with a paintbrush quite yet. Fingers are great for making irregular stripes and wonky dots, several at a time if you like. In this exercise, experiment with the ways your fingers can create beautiful pattern and texture. Drag your fingers to create cool and warm-toned stripes and pounce for a flurry of dots. Finger painting is a simple way to make an expressive artwork that is completely unique to the artist.

Let's Go!

1. Use your first three fingers to pick up two cool colors of craft paint and, starting at the top edge of the paper, drag vertical, downward strokes onto the page (fig. 1). Repeat across the paper.

2. Clean your fingers. Keep a few dampened paper towels at the workstation for this. Now pick up two different cool colors and drag a few horizontal stripes across the page (fig. 2).

3. Wipe your fingers again. Flip the page. Now drag a few warm colors onto the page in vertical, downward strokes (fig. 3). Repeat until the balance looks good to you.

4. Dip your fingertips in paint and pounce dots down the center of the sheet (fig. 4). Be sure to touch down with the tip of your fingers only to get the best dots. Alternate colors until you are happy with the effect.

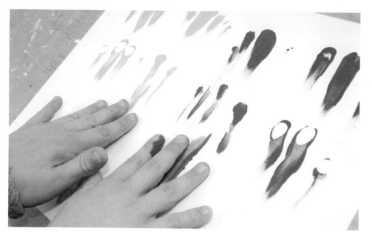
Fig. 1: *Drag two cool colors vertically down the page.*

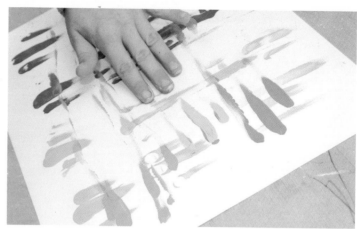
Fig. 2: *Drag two new cool colors horizontally across the page.*

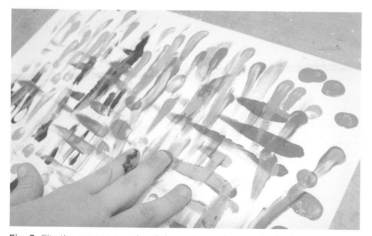
Fig. 3: *Flip the paper around and drag warm colors vertically down the page.*

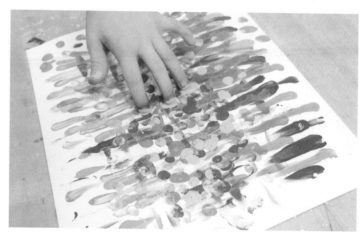
Fig. 4: *Add multicolor dots at center.*

Inspiring Artist: Flora Bowley

Flora Bowley routinely puts fingers to canvas when she paints and with wonderful results. Flora is an internationally celebrated painter, workshop facilitator, author of *Brave Intuitive Painting*, and an artist who inspires others. Combining twenty years of professional painting experience with a background as a yoga instructor, massage therapist, and lifelong truth seeker, Flora's unique and holistic approach to the creative process has inspired thousands to "let go, be bold, and unfold." Be inspired at braveintuitiveyou.com

Cocoon by Flora Bowley

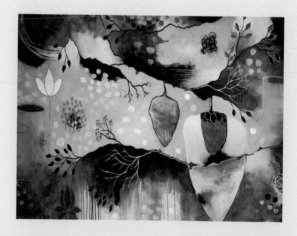

GO WITH THE FLOW:
15-Minute Intuitive Painting

→ Paper palette or coated paper plate

→ Acrylic paint

→ Paintbrushes

→ Rubbing alcohol

→ Paper towel

→ Timer

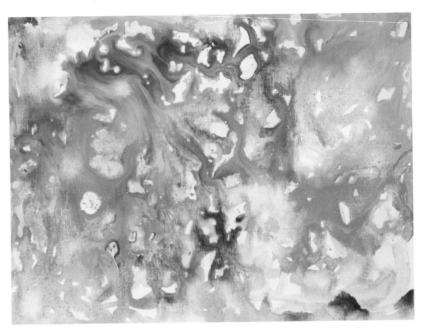

PAINT FROM YOUR SOUL. IN THIS 15-MINUTE, INTUITIVE, WET-INTO-WET COLOR-MINGLING PAINTING, USE WATERED DOWN ACRYLICS, DYES, AND RUBBING ALCOHOL ON CANVAS BOARD. Make puddles of color and allow the blending and flowing of colors to happen naturally. Let go of expectations. Play. Be free. Drip on alcohol. Spatter on flecks of water. Add color without too much planning or thought, just let your intuition guide you. Work quickly! Once the timer sounds, you're done. Walk away and wait for the surprising result when the paint has dried. No matter how many times you repeat this project, the results will always be fun and different.

Practice, Practice!

—Try this project with slightly thicker paint, the consistency of heavy cream. Then tilt and twist the canvas board to encourage movement and a flow of the colors.

—Set up three boards at a time and move from piece to piece, quickly adding colors and alcohol. Turn on a favorite song and use the song as your timer. After three repeats of the song, your work is done.

Let's Go!

1. You will want materials handy for this project since it is very fast-paced. Everything placed in clear view will allow for a more spontaneous selection of color and materials as you move through the steps. Arrange your workspace something like the example shown: paper palette with paint selections, brushes, alcohol in a dish, paper towel, bucket for rinsing brushes, dyes, and a timer (fig. 1). I used my cell phone timer.

2. Set your timer! Begin by making a watery blob of acrylic color (fig. 2). Move it around. Add a second color and gently coax a bit of mixing. It is very important not to overwork the blends. Let the water do the blending work. Your only job is to be a bit of a guide. Leave some areas blank. The shapes of the color puddles will be so much more interesting if you allow voids in the paint to remain.

3. Once you've worked outward a bit and have some nice color blends, spatter a bit of rubbing alcohol over the richest color sections (fig. 3). Watch as the color retreats from the droplets of

Fig. 1: *Prepare the materials and set the timer.*

Fig. 2: *Make puddles of bold color.*

Fig. 3: *Drip alcohol onto the puddles of color to create voids and patterns.*

Fig. 4: *Create swirls through several colors.*

Fig. 5: *Drop blobs of white paint on the painting.*

alcohol. Don't overdo it. Move on to the next section and continue painting. (Note: Use an old brush for the alcohol drips and save your nice brushes for color.)

4. Use your paintbrush to pull swirls and curves through a multicolor section of paint (fig. 4). This is similar to marbleizing paper. It's a beautiful effect but, again, don't overdo it. The beauty of this project comes from a bit of manipulation and a lot of letting go and allowing the water to do its thing.

5. Apply dollops of thicker white paint (fig. 5). Watch as the edges of each drop of paint splinter outward into the watery colors, while the center stays pure white, almost like a sprinkling of stars. Add these anywhere there is an accumulation of color to lend more brightness.

When the timer goes off at the 15-minute mark, you are done. No cheating! Now wait patiently. Come back in a few hours to see the result.

Author's Inspiration

The go-with-the-flow style of painting is something I turn to when I am feeling super-creative and energized. I trust my intuition and mood to guide my color choices and the movement of my paintbrush across the canvas. In this example, I was feeling warm and happy—the colors show it!

Go With the Flow by Stephanie Corfee

THAT'S MY JAM:
Painting a Song

TRANSLATE YOUR FAVORITE SONG INTO A PAINTING. IS IT HAPPY? SAD? WHAT COLOR COMES TO MIND WHEN YOU HEAR IT? Make an abstract painting to reflect the sound, mood, and spirit of your favorite song. Listen to it as you paint. Create smooth curves during the melody and spatters and pounces during the drum solo. Or, use certain colors for drums and other colors for guitar or piano. Be creative. The steps in this exercise are just suggestions to get you started. Paint however the song moves you!

MATERIALS

→ Stretched canvas

→ Source of music

→ Acrylic paint

→ Paper palette or coated paper plate

→ Paintbrushes

Let's Go!

1. Start by setting your chosen song to repeat over and over again. First, listen once and decide on an overall color feeling for your song. If it is cheerful, maybe yellow seems right. If it is sad, it could be blue. Paint the canvas using the selected color to create a base for the next steps (fig. 1).

2. Now listen to the song and concentrate on colors and shapes. See if you can conjure a picture in your mind. Maybe slow parts sound like waves of blue, and faster parts make you think of red and pink circles. Use your creativity to interpret the sounds you hear into colorful forms on the canvas (fig. 2). It may take two or three repeats of the song to complete this step. That's OK; it's not a race. Have fun. Dance while you paint. Move your brush to the rhythm.

3. To finish your painting, listen once more while paying attention to tempo (speed) and beat. Use two brushes like drumsticks, if you like, to tap paint onto the canvas (fig. 3). Tap quickly or slowly. Watch as you create texture and sharpness on the surface. Go back to one brush and add wavy lines that move across the canvas to the tempo of the song. There is no wrong way to feel music. Just go with it and paint as you sway and move to the song.

4. OPTIONAL: If you like, finish by adding lyrics or symbols that represent the song.

Fig. 1: *Paint a base color for the song.*

Fig. 2: *Paint to the music using color and shape.*

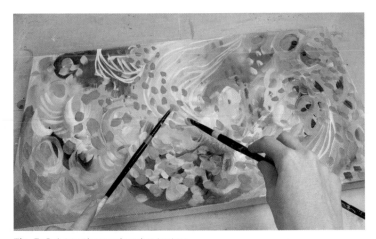

Fig. 3: *Paint to the music using texture.*

Little Hands

This is a mature concept better suited to older kids who can listen and interpret music. But small children may surprise you. They will certainly have tons of fun if they approach the project more like a paint-and-dance party. Turn on some fun music. Set out paint and some large art paper. Then instruct your little ones to dance while they paint—and make the brush dance as well. From my experience, this experiment is very popular and elicits lots of giggles and requests for repeats.

Inspiring Artist: Vassia Alaykova

This vibrant piece by Vassia Alaykova is a jaw-dropping example of how music can inspire art. Vassia's works are beautiful watercolors with a whimsical feel, fanciful stories inspired by music, color, nature, fairy tales, and poetry. Her work has been displayed in galleries and is

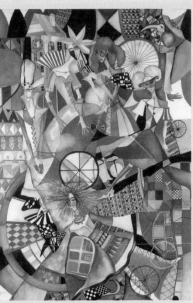

owned by collectors around the world. Her first exhibition was held in Berkeley, California, when she was only 14-years old. See more of her creations at vassiart.com.

Dream Circle by Vassia Alaykova

ART JOURNALING

ART JOURNALING IS A GREAT WAY TO EXPRESS YOURSELF WITH ART EVERY DAY. Work in a used notebook or fill a blank one with layers of paint, textures, collage, drawings, stamps, and more. A great way to choose inspiration for your daily journal entries is to translate one word per session into art. For example, if the day's word is *ballerina*, you might paint tutus and twirling lines using frothy pinks, tulle textures, and feathers. For this project, the word is *nature*. Make a visual journal entry that communicates nature from your creative point of view.

MATERIALS

→ Notebook, new or used

→ Craft paint

→ Paintbrushes

→ Paper palette or coated paper plate

→ Tissue paper

→ Decoupage medium, mat medium, or white glue

→ Poster board, for stencils

→ Scissors

→ Stamps

→ Black paint pen or pencil

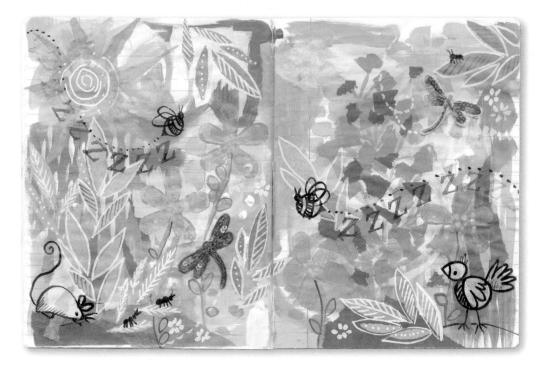

Let's Go!

1. Paint a base of color for the journal spread using craft paint (fig. 1). Choose colors that work with the theme of the chosen word. Rather than painting a solid block of color, use analogous colors blocked in with textures and brushstrokes.

2. Arrange collage pieces on the spread and adhere them with mat gel medium, glue, or decoupage medium (fig. 2). Think about layout and try to establish some balance. Use complementary colors to achieve contrast with the background.

3. Create simple, themed stencils by cutting shapes from plain cardstock. Place the stencils on the art and "pounce" color into the cutout areas to create texture in the design (fig. 3). Repeat the stencil on other areas of the artwork in various colors. This creates a sense of repetition and provides bold color.

4. Finish the painting with drawings, lettering, and all the fine details that make your artwork special (fig. 4). Use a paint pen or pencil for the drawings. Add hand-lettering or fun alphabet stamps. Pay lots of attention to small details. Those are what turn ordinary art into something more charming and engaging. Give the viewer lots of special little secrets to discover.

Fig. 1: *Paint a base of color.*

Fig. 2: *Add collage pieces.*

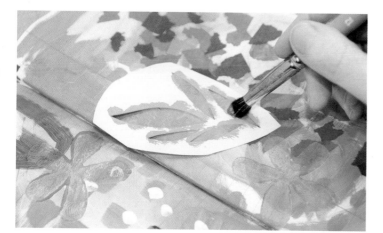

Fig. 3: *Layer with stencils.*

Fig. 4: *Add drawings, lettering, and details.*

Inspiring Artist: Jennifer Orkin Lewis

Here's a lovely example of a daily art journal created by Jennifer Orkin Lewis, an illustrator based in a small town outside New York City. "My paintings are inspired by small everyday things I see: flowers, bugs, birds, and people. I usually paint with gouache, but I also use other media. I do a 30-minute painting-a-day in my sketchbook." See more of Jennifer's work at augustwren.com.

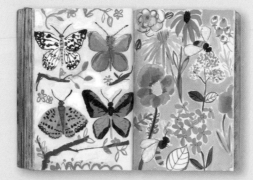

Butterflies and Flowers by Jennifer Orkin Lewis

Little Hands

To get little ones on the right track from the start, choose a smaller size journal or notebook that will be easier for them to fill. Work on an alphabet theme, painting one page at a time with one design element rather than a whole spread full of details. It's wonderful to start a daily practice of creating with small children. Modifying a project to their ability level will help them get great results and motivate them to repeat it again and again.

HAND-LETTERED WOOD SIGNS:
Decorative Reverse Painting

MATERIALS

→ Scrap wood or panel from a hobby shop

→ Craft paint

→ Paintbrushes

→ Paper palette or coated paper plate

→ Poster board

→ Black marker

→ Scissors

→ Low-tack glue stick

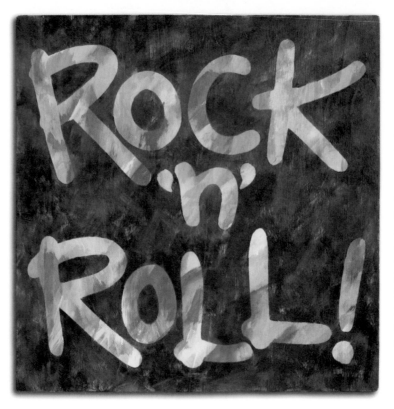

WORD ART IS ALWAYS A CONVERSATION-STARTER. IT CAN BE INSPIRING, PERSONAL, FUNNY, OR MEANINGFUL. A perfect combination of sentiment and decoration, it stands as a beautiful visual reminder that can be displayed for all to see. In this exercise, create a fun, colorful, and textural quote or catch phrase using hand-drawn and cut letters, plus simple paint techniques that combine for a super-stylish result.

Practice, Practice!

—Make a lemonade stand sign this way and you'll have the snazziest business on the block!

—Create a family treasure, a handmade Happy Birthday sign that you bring out for each party every year. Add small wood triangles to the back so it can stand on a tabletop or add hardware on the back and hang it on the wall.

Let's Go!

1. Grab your boldest craft paints and create a nice, messy, scribbly background of color on a piece of scrap wood or a panel from a craft store (fig. 1). Work lots of variety into the brushstrokes since the pattern you create is what will show through the lettering in your final artwork. Allow the wood to dry.

2. Cut a piece of poster board the same size as your wood panel so you can sketch your letters to scale. Draw and cut the word or phrase of your choice to fit on the panel any way you like (fig. 2). Keep your letters simple and fairly chunky so that they will look nice and bold after the paint is applied.

3. Use a low-tack glue stick to temporarily adhere the letters to the painted and dried board (fig. 3).

Fig. 1: *Paint a textural background. Let dry.*

Fig. 2: *Draw and cut the letters.*

Fig. 3: *Attach the letters to the background.*

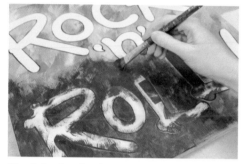

Fig. 4: *Dry brush paint over the entire board. Let dry.*

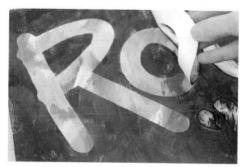

Fig. 5: *Gently peel away the letters.*

4. Choose a bold paint color that will contrast nicely with the original colors. Use a dry brush, dipped in paint and blotted a little on paper towel, to create scratchy, sketchy strokes all over the surface of the board (fig. 4). Fill all areas around your letters and try not to get any paint under the edges of the cutouts.

5. Once the paint is dry, peel away the letters to reveal your colorful word or phrase (fig. 5).

Inspiring Artist: Kylee R. Wojtkiewicz

Words and wood signs are two things Kylee Wojtkiewicz knows a lot about. "Ever since I was a little girl I have always loved creating art using bright, bold colors." Now she takes those beautiful colors and paints them on gorgeous wood signs families can cherish for years to come. See more of Kylee's wood signs at etsy.com/shop/indiehaus.

Anna by Kylee R. Wojtkiewicz

MATERIALS

→ Black marker

→ Typing paper

→ Watercolor paper

→ Pencil

→ Watercolor paint

→ Eraser

Practice, Practice!

—Make nursery art for a newborn with the baby's name painted in watercolor. It's guaranteed to be a favorite and cherished gift.

—Create notecards with watercolor words on the front: Try "Thank You," "Congratulations," or "Thinking of You." Folks will be so touched by your thoughtfulness.

WE EXPRESS OURSELVES THROUGH OUR SIGNATURE. It's one of a kind. Your signature is uniquely you. In this cool project, translate your finest handwritten signature into a personalized autograph painting using blended watercolors. Embrace your bold, loopy L. Celebrate your sharp, angular A. There won't be another signature quite like yours.

Let's Go!

1. Sign your name in black marker on a piece of typing paper (fig. 1). Go back over the signature and carefully thicken all of the letters. Bold, thick letters will give you lots of room to paint.

2. Using a light box or working at a window on a sunny day, lightly trace the outline of your signature onto a piece of watercolor paper (fig. 2).

3. Working from left to right, begin filling the outlines with one color after another (fig. 3). Choose a new color each time you go back to the palette. Paint a section just in front of the previous one and allow the edges of the two colors to just touch. Rinse the brush and then blend the damp edges with a little clean water. Continue this technique until the entire name is filled.

4. When the watercolor is completely dry, erase any obvious pencil outlines (fig. 4).

Fig. 1: *Sign your name and make it thicker.*

Fig. 2: *Trace the outline of your name onto watercolor paper.*

Fig. 3: *Paint your name with a variety of colors.*

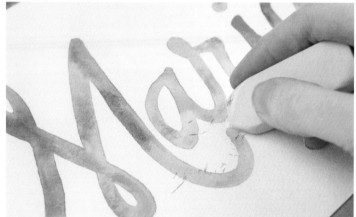

Fig. 4: *Erase the pencil lines.*

Inspiring Artist: Jeanetta Gonzales

Hand lettering comes in many forms as seen in this bold piece by Jeanetta Gonzales. Jeanetta, a multi-disciplinary artist and designer based in Los Angeles, specializes in surface design, hand lettering, textile art, and graphic design. Her work style is energetic, colorful, and graphic. See more of her work and visit her blog at jeanettagonzales.com.

Pizza Party! by Jeanetta Gonzales

GO BIG:
Painting Large Surfaces

MATERIALS

→ Large painting surface

→ Large and small paintbrushes

→ Acrylic paint and craft paint

→ Paper palette or coated paper plate

→ Paint pens

→ Stencils and stamps (optional)

GIVING KIDS THE OPPORTUNITY TO CREATE ON LARGE SURFACES CAN REALLY STRETCH THEIR CREATIVE MUSCLES AND INCREASE THEIR CONFIDENCE. It feels special and grand. In this project, encourage kids to GO BIG by painting on a large sheet of paper, cloth, or canvas with big brushes and bold colors. Paint with your whole arm, not just your wrist. Squat, jump, and make big, sweeping arcs, strokes, and drips. Grab a partner to help you cover all that wide-open space, but don't feel pressured to finish in one session. The beauty of painting a large canvas is that it can develop over time, with new elements added, each session creating memories to keep.

Practice, Practice!

—Tack a long piece of wide, brown craft paper to the wall. Choose a theme like *magic forest* and make a group mural with your siblings or friends. Switch places every fifteen minutes or so to work on an area someone else started. This is fun for collaborating and moving your body. Remember to have all the artists pose for a photograph in front of the mural when you're done.

—Paint a tall mural on paper or on a wall to use as a growth chart. Paint it in bold, abstract colors. Each time your record a measurement, decorate around the mark for an ever-changing piece of art.

Let's Go!

1. Paint some large, sweeping arcs and lines with your whole arm in play using a long-handled paintbrush (fig. 1). Turn the canvas once or twice to change the direction of the lines.

2. Choose four to six colors and begin to block in the large spaces (fig. 2). Paint loosely, letting the brushstrokes show. Don't worry about perfection. With larger canvases, the first step is often just getting a base of color applied. Then you can move toward refining the shapes and adding details. Remember that white paint is your friend. Use white paint here and there and blend it into your colors right on the canvas to add some life to your color palette.

3. Put on some music and get your body into the movement. Crouch low and reach your arm across your body to draw lines (fig. 3). Paint loops and pounce on dots. If you are lively and moving while you paint, that liveliness will translate into the marks you make. Find a few areas on the canvas with the same color and connect them with a long line or arc. Think of it like a color bridge. Notice how it gives structure and a connected feeling to the painting.

4. Switch to a smaller brush to add pattern, doodles, words—even stamps and stencils (fig. 4). Rotate the canvas occasionally to work on different areas. Put your personality into the piece and give the viewer lots of fun surprises to discover.

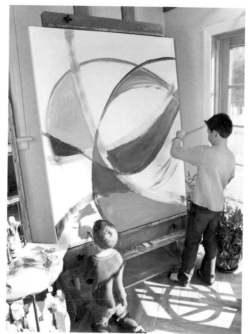

Fig. 1: *Divide the canvas, using large arcing brushstrokes.*

Fig. 2: *Block in color.*

Jennifer Mercede takes oversized art to a whole new level with this amazing twenty-four-foot-high mural for the Grand Rapids Children's Museum. Jennifer's art is bright, bold, whimsical, spontaneous, and free. She follows her intuition and has fun making art; she believes there is no such thing as a mistake and likes to create new rules. See her art, large and small, at jennifermercede.com.

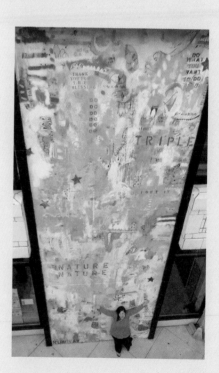

Rockin' Colors Mural by Jennifer Mercede

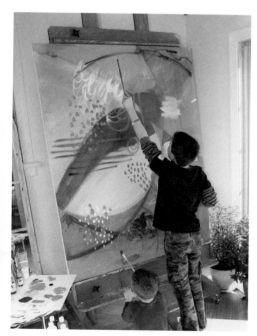

Fig. 3: *Add elements to create movement and unity.*

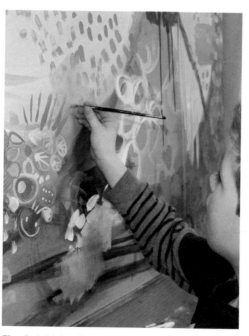

Fig. 4: *Add details to give the painting personality and surprise.*

WHAT A DRAG:
Scraped-Color Painting

BRUSHES AREN'T THE ONLY PAINTING TOOLS IN TOWN! Apply paint with just about anything you can think of to create different thicknesses and textures. In this exercise, create a scraped-color painting by dragging and overlapping acrylic paint with old plastic gift cards or expired credit cards instead of brushes and then add texture and pattern with homemade cardboard tools. Prepare a few extra boards at the start because you'll want to make more than one.

MATERIALS

→ Smooth, sturdy cardboard

→ Old plastic credit cards and gift cards

→ White primer, gesso, or acrylic paint

→ Corrugated cardboard squares

→ Paper palette or coated paper plate

→ Acrylic paints

→ Scissors

Let's Go!

1. Prime a piece of heavy, smooth cardboard with white gesso or white paint (fig. 1). While the paint dries, cut different shaped "teeth" into a few squares of sturdy cardboard to use as scraping tools.

2. Once the board is completely dry, begin dragging streaks of paint across the board with a plastic card (fig. 2). For bolder strokes, hold the card flatter to the table and drag it with a light touch. Hold the card more vertical and apply pressure to scrape paint away and leave just a bit of color. Try picking up a different color on each corner of the card and then dragging the card to blend and streak the two colors.

3. Overlap the colors to create blends (fig. 3). Blue over yellow will result in green in the overlap, for example. Continue filling the board with different colors and different length strokes, working in every direction.

4. While the surface is still wet, use the texture tools to scrape away stripes of color to reveal the color beneath (fig. 4). Continue working until you are happy with the result.

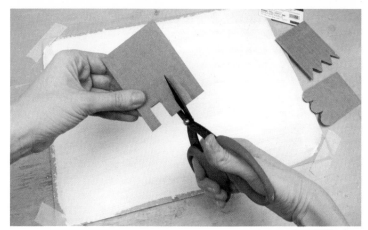

Fig. 1: *Prime the smooth cardboard and cut the corrugated cardboard into scraping tools.*

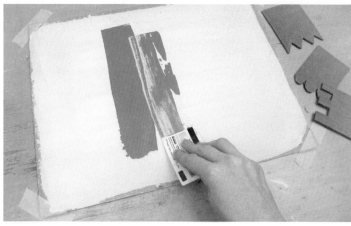

Fig. 2: *Drag single and dual colors with a plastic card.*

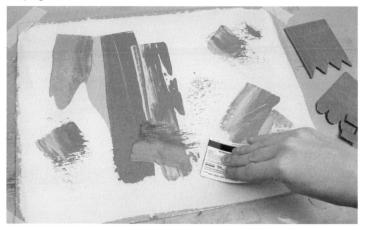

Fig. 3: *Overlap and layer the colors to blend.*

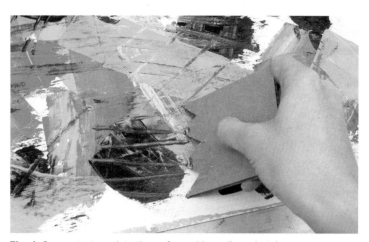

Fig. 4: *Scrape textures into the surface with cardboard tools.*

Inspiring Artist: Elena Petrova

This piece by Elena Petrova shows a delightful use of palette knives to spread paint onto the canvas. Elena is a Canadian artist whose paintings show life the way she sees it: vibrant, joyful, bold, and magnificent. "My paintings are my feelings on canvas. My goal is to create an opportunity for the viewer to find various meanings in the painting." Learn more at etsy.com/shop/ElenasArtStudio.

Sweet Summer by Elena Petrova

Practice, Practice!

—Choose colors to coordinate with your room decor. Create an abstract design that is custom-made for the space.

—Work this technique on canvas and when it's dry, use the painted fabric to cover a stool or bench.

RESOURCES

A.C. Moore
acmoore.com

Blick Art Supply
dickblick.com

JoAnn Fabric & Craft Stores
joann.com

Michaels
michaels.com

Utrecht
utrechtart.com

Dharma Trading
dharmatrading.com

Home Depot*
homedepot.com

Lowes*
Lowes.com

*These are great resources for sturdy, inexpensive, rinsing and storage buckets, paintbrush packs, and rolls of kraft or contractor's paper for protecting work surfaces.

Left: Collaborative painting by Stephanie Corfee, Reegan, Riley, and Malley Behles

CONTRIBUTING ARTISTS

Bari J. Ackerman
barijdesigns.com

Amy Adams
etsy.com/shop/RubyMoonDesigns

Vassia Alaykova
vassiart.com

Traci Bautista
treicdesigns.com

Anne Bollman
annewashereandthere.com

Sarah Bonetti
etsy.com/shop/liquidocolorato

Flora Bowley
braveintuitiveyou.com

Wendy Brightbill
agirlandherbrush.com

Maria Carluccio
mariacarluccio.com

Jo Chambers
studio-legohead.com

Barbara Chotiner
blankbzdesignstuff.com

Carolina Coto
carocoto.com

Stephanie Corfee
stephaniecorfee.com

Jacqui Crocetta
jacquicrocetta.com

Madeline de Kemp
makeartbehappy.blogspot.com

Jenny Doh
blog.crescendoh.com

Katie Doucette
polkadotmitten.com

Tracey English
tracey-english.blogspot.co.uk

Alicia Ferrara
etsy.com/shop/TotallyTiedAndDyed

Pam Fish
etsy.com/shop/fishwarp

Alex Leigh Franklin
alexleighfranklin.com

Zach Franzen
atozach.com

Jeanetta Gonzales
jeanettagonzales.com

Lesley Grainger
lesleygrainger.com

Catherine Herold
fire-spark.net

Zoë Ingram
zoeingram.com

Vanessa Kiki Johanning
vanessajohanning.com

Jennifer Orkin Lewis
augustwren.com

Victoria Johnson
Isadora Grasso
victoriajohnsondesign.com

Rebecca Jones
drawnbyrebeccajones.com

Asta Kundelytė
artbyasta.com

Lauren LaFond
Jennifer Mercede
jennifermercede.com

Christine Mercier
etsy.com/shop/artcm

Jasmine Nixon
etsy.com/shop/xnotedx

Elena Petrova
etsy.com/shop/ElenasArtStudio

ACKNOWLEDGMENTS

Melissa Ramirez
nuviart.com

Peter H. Reynolds
peterhreynolds.com

Patti Robrahn
etsy.com/shop/spyingonmermaids

Cynthia Shaffer
cynthiashaffer.com

Renae Schoeffel
etsy.com/shop/renaeschoeffelart

Nancy Standlee
nancystandlee.com

Jessica Swift
JessicaSwift.com

Toni Thomas
etsy.com/shop/toastcrafts

Heather Volkel
etsy.com/shop/SomewhereFound

Valerie Wieners
valeriewienersart.com

Jane Wilcoxson
JaneWilcoxson.com

Kylee R. Wojtkiewicz
etsy.com/shop/indiehaus

I'd like to thank the team at Quarry, especially Joy and Betsy who were terrific throughout.

I'd like to thank to the INCREDIBLE group of contributing artists whose work helped make these pages beautiful and inspiring.

I would like to thank my family, who minded my closed studio door while I was writing, but jumped in to help with project set-up and art-making when it was open.

ABOUT THE AUTHOR

Stephanie Corfee is an artist from the Philadelphia area. She works from a home studio while also caring for her three young boys. "They love to be in the studio with me! It's an inspiring place full of great light, colors, textures, and endless art supplies. Working in there is magic."

Stephanie's love for making art with kids is evident even in her personal work, which is full of whimsy and playful color. She works predominantly in acrylics and watercolor. Pencil sketches and ink doodles are also favorites. Her original paintings have been sold all over the country. And her work is licensed and printed on products such as bedding, scarves, totes, collectibles, greeting cards, and more.

Stephanie offers online workshops through her website, stephaniecorfee.com, and is the author/illustrator of several art instructional books. Paint Lab for Kids is her fourth effort, and a fifth book is forthcoming. "Teaching kids, whether in books, in person, or online is just what I love to do. Helping kids gain confidence in their uniqueness and style is what inspires me most. It's one of the best feelings in the world."

Left: *Magic* by Stephanie Corfee

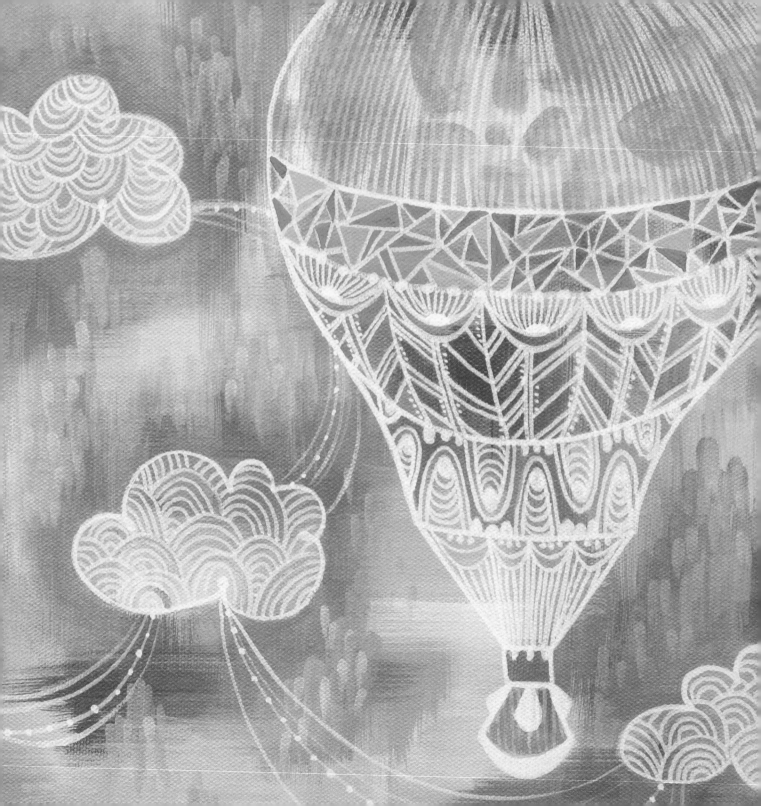

INDEX

Abstract Mini-Collection, 78–79
Ackerman, Bari J., 65
acrylic paint
 Abstract Mini-Collection, 78–79
 Acrylic Blending, 24–25
 Acrylic Skins Collage, 50
 Altered Photos: Love You Bunches
 Painting, 104–105
 Clean & Bright Acrylics, 42–43
 Collaborative Painting, 82–83
 Drip-Drop Water Techniques, 32–33
 Energy Burst: High-Contrast Minimalist
 Painting, 70–71
 Finger-Painting Power, 118–119
 Glue "Batik" Fabric Paint, 92–93
 Go Big: Painting Large Surfaces, 130–131
 Go with the Flow: 15-Minute Intuitive
 Painting, 120–121
 introduction to, 14
 Kitchen Sink Painting: Extreme Mixed Media,
 98–99
 Nine Purple Circles: Dynamic
 Monochromatic Painting, 84–85
 On a Roll: Continuous Surface Pattern,
 110–111
 Peek-a-Boo Painting: Colorful Cityscape,
 30–31
 Stamped Patterns That Pop, 26
 That's My Jam: Painting a Song, 122–123
 That's So You! Stylized Self-Portraits, 116–117
 What a Drag: Scraped-Color Painting,
 132–133
 White Bright: Using White to Expand
 Your Palette, 86–87
Adams, Amy, 37
Alaykova, Vassia, 123
Altered Photos: Love You Bunches Painting,
 104–105
analogous colors, 15
Anna (Kylee R. Wojtkiewicz), 127
Antoin (Melissa Ramirez), 49
Art Journaling, 124–125
Autograph Painting, 128–129

Balloon Ride (Stephanie Corfee), 140
Bautista, Traci, 39
Behles, Malley, 134
Behles, Reegan, 134
Behles, Riley, 134
Boho Sea Turtle (Bari J.), 65
Bollman, Anne, 23

Bonetti, Sarah, 81
Bowley, Flora, 119
Brightbill, Wendy, 85
brushes, 14, 16, 18
Brushstroke Blooms, 60–61
Bubbly Print Balloons, 62–63
Butterflies and Flowers (Jennifer Orkin Lewis),
 125

Can't Resist Tie-Dye, 44–45
canvases, 16
Carluccio, Maria, 31
Chambers, Jo, 55
Chotiner, Barbara, 35
Clean & Bright Acrylics, 42–43
cleanup, 14, 18
Cocoon (Flora Bowley), 119
Coffee-Saurus: Sepia Tonal Painting
 with Coffee, 102–103
Collaborative Painting, 82–83
color wheels, 15
complementary colors, 15
Copy That: Folded-Paper Insect Monoprints,
 36–37
Corfee, Stephanie, 59, 61, 83, 89, 107, 121, 134,
 138, 140
Coto, Carolina, 67
craft paint
 Art Journaling, 124–125
 Brushstroke Blooms, 60–61
 Copy That: Folded-Paper Insect Monoprints,
 36–37
 Daydream Painting: Working with Soft
 Pastel, 94–95
 Disappearing Paint: Subtractive Techniques,
 34–35
 Doodle on a Painting, 58–59
 Drip-Drop Water Techniques, 32–33
 Finger-Painting Power, 118–119
 Glue "Batik" Fabric Paint, 92–93
 Go Big: Painting Large Surfaces, 130–131
 Hand-Lettered Wood Signs: Decorative
 Reverse Painting, 126–127
 If I Had Wings: Decorative Painting, 64–65
 Lightning Storm: Decoupage & Rubbing
 Technique, 108
 Ombré Ocean, 72–73
 Painting On Water: Marbled Paper Galaxy
 Painting, 56–57
 Paper Towel Transfer Method: Moths 'Round
 the Moon, 112–113

Partner Paint-By-Number, 76–77
Peek-a-Boo Painting: Colorful Cityscape,
 30–31
Pencil Eraser Pointilism, 74–75
Quirky Pet Portrait, 54–55
Stamped Patterns That Pop, 26
Tissue Transparency Collage, 96–97
Whole World in Your Hand: Painting
 in Miniature, 66–67
Wood Plank Zebra: Staining Wood
 with Paint, 100–101
crayons
 Can't Resist Tie-Dye, 44–45
 Draw-to-Paint: Water-Soluble Drawing
 Tools, 40–41
Crocetta, Jacqui, 25

Daydream Painting: Working with Soft Pastel,
 94–95
decoupage medium, 14
Dimensional Outlines: Stained Glass
 Watercolor, 106–107
Disappearing Paint: Subtractive Techniques,
 34–35
Doh, Jenny, 105
Doodle on a Painting, 58–59
Dot, A (Peter H. Reynolds), 53
Doucette, Katie, 101
Draw-to-Paint: Water-Soluble Drawing Tools,
 40–41
Dream Circle (Vassia Alaykova), 123
Drip-Drop Water Techniques, 32–33
drop cloths, 14, 16
"82" (Zoë Ingram), 71
Energy Burst: High-Contrast Minimalist
 Painting, 70–71
English, Tracey, 97

Ferrara, Alicia, 57
Find Your Joy (Rebecca Jones), 87
Finger-Painting Power, 118–119
Fish, Pam, 93
Floral Excitement (Valerie Wieners), 43
Floral Graffiti (Traci Bautista), 39
Flying Faith (Lesley Grainger), 33
Franklin, Alex Leigh, 41
Franzen, Zach, 103
French Bulldog Love (Anne Bollman), 23

gel medium, 14
glue, 14

Left: *Balloon Ride* by Stephanie Corfee

Glue "Batik" Fabric Paint, 92-93
Go Big: Painting Large Surfaces, 130-131
Gonzales, Jeanetta, 129
gouache. See Ombré Ocean, 72-73
Go with the Flow: 15-Minute Intuitive Painting, 120-121
Go With the Flow (Stephanie Corfee), 121
Grainger, Lesley, 33
Grasso, Isadora, 95

Hand-Lettered Wood Signs: Decorative Reverse Painting, 126-127
Handmade Bubble Print Notebook (Jasmine Nixon), 63
Herold, Catherine, 45
Hope, or Let's Just Be (Jessica Swift), 27
House on the Hill (Tracey English), 97

If I Had Wings: Decorative Painting, 64-65
Ingram, Zoë, 71
Ink-sect (Amy Adams), 37
Inspire (Cynthia Shaffer), 113

Johanning, Vanessa "Kiki," 99
Johnson, Victoria, 95
Jones, Rebecca, 87

Kaleidoscope Colors, 80-81
Kemp, Madeleine de, 117
Kids Collaboration (Lauren LaFond and Stephanie Corfee), 83
Kissy Fish (Patti Robrahn), 77
Kitchen Sink Painting: Extreme Mixed Media, 98-99
Kundelyte, Asta, 75

LaFond, Lauren, 83
Lewis, Jennifer Orkin, 125
Little Barn Necklace (Carolina Coto), 67
Little Mermaid and Friends (Madeleine de Kemp), 117

Magic (Stephanie Corfee), 138
markers
 Autograph Painting, 128-129
 Bubbly Print Balloons, 62-63
 Hand-Lettered Wood Signs: Decorative Reverse Painting, 126-127
 If I Had Wings: Decorative Painting, 64-65
 introduction to, 14
 Partner Paint-By-Number, 76-77
 Watercolor Bleeding, 22-23
 Watercolor Blob Characters, 48-49
 Whole World in Your Hand: Painting in Miniature, 66-67
Mercede, Jennifer, 131
Mercier, Christine, 109

Merle's Treasured Garden (Stephanie Corfee), 61
MultiSwirl (Pam Fish), 93
Mystical Potion Painting, 52-53

Name Splatter Paintings (Catherine Herold), 45
Nine Purple Circles: Dynamic Monochromatic Painting, 84-85
Nixon, Jasmine, 63

Ombré Ocean, 72-73
On a Roll: Continuous Surface Pattern, 110-111
One of a Kind: Subtractive Monoprints, 38-39
Outer Space Marbled T-Shirt (Alicia Ferrara), 57

Painting On Water: Marbled Paper Galaxy Painting, 56-57
Paper Towel Transfer Method: Moths 'Round the Moon, 112-113
Partner Paint-By-Number, 76-77
Peek-a-Boo Painting: Colorful Cityscape, 30-31
Pencil Eraser Pointillism, 74-75
pencils
 Acrylic Skins Collage, 50
 Art Journaling, 124-125
 Autograph Painting, 128-129
 Coffee-Saurus: Sepia Tonal Painting with Coffee, 102-103
 Daydream Painting: Working with Soft Pastel, 94-95
 Dimensional Outlines: Stained Glass Watercolor, 106-107
 Draw-to-Paint: Water-Soluble Drawing Tools, 40-41
 If I Had Wings: Decorative Painting, 64-65
 introduction to, 14
 Kaleidoscope Colors, 80-81
 Ombré Ocean, 72-73
 Pencil Eraser Pointillism, 74-75
 Photo Inspiration Color Study, 88-89
 Watercolor Blending, 22-23
 Watercolor Blob Characters, 48-49
 White Bright: Using White to Expand Your Palette, 86-87
pens
 Art Journaling, 124-125
 Bubbly Print Balloons, 62-63
 Collaborative Painting, 82-83
 Doodle on a Painting, 58-59
 Go Big: Painting Large Surfaces, 130-131
 If I Had Wings: Decorative Painting, 64-65
 introduction to, 14
 Kitchen Sink Painting: Extreme Mixed Media, 98-99
 Quirky Pet Portrait, 54-55

That's So You! Stylized Self-Portraits, 116-117
Watercolor Blob Characters, 48-49
Whole World in Your Hand: Painting in Miniature, 66-67
Wood Plank Zebra: Staining Wood with Paint, 100-101
Petrova, Elena, 133
Photo Inspiration Color Study, 88-89
Pizza Party! (Jeanetta Gonzales), 129
Pods + Blossoms (Stephanie Corfee), 59
primary colors, 15
Pug in Pucci (Jo Chambers/Studio Legohead), 55

Queen Victoria Pineapple (Alex Leigh Franklin), 41
Quirky Pet Portrait, 54-55

Ramirez, Melissa, 49
ReadySetGrow (Barbara Chotiner), 35
Reynolds, Peter H., 53
Ride (Jenny Doh), 105
Robrahn, Patti, 77
Rockin' Colors Mural (Jennifer Mercede), 131

Schoeffel, Renae, 79
secondary colors, 15
Seelie Court (Renae Schoeffel), 79
Shaffer, Cynthia, 113
Shattered Flower (Stephanie Corfee), 107
Ship in Bottle 1 (Victoria Johnson), 95
Ship in Bottle 2 (Isadora Grasso), 95
Silly Bird (Nancy Standlee), 51
Silly Mixed Up Wire Bird (Vanessa "Kiki" Johanning), 99
smocks, 14, 16, 18
Soft Bubble Hues (Sarah Bonetti), 81
Splash Seahorse (Jane Wilcoxson), 29
Spring Showers (Katie Doucette), 101
Stamped Patterns That Pop, 26
Standlee, Nancy, 51
storage, 18
Summer Cadence (Jacqui Crocetta), 25
Sunny Day (Asta Kundelyte), 75
supplies, 14, 16
Sweet Summer (Elena Petrova), 133
Swift, Jessica, 27

tape, 14
Tea Time: Elephant and Mouse (Zach Franzen), 103
tempera paint
 Brushstroke Blooms, 60-61
 Bubbly Print Balloons, 62-63
 Copy That: Folded-Paper Insect Monoprints, 36-37

Disappearing Paint: Subtractive Techniques, 34–35
One of a Kind: Subtractive Monoprints, 38–39
Quirky Pet Portrait, 54–55
Whole World in Your Hand: Painting in Miniature, 66–67
That's My Jam: Painting a Song, 122–123
That's So You! Stylized Self-Portraits, 116–117
Thomas, Toni, 111
time management, 16
tips and tricks, 16
Tissue Transparency Collage, 96–97

Underground Exploration (Maria Carluccio), 31
Untitled Mixed Media 2014 (Christine Mercier), 109

Volkel, Heather, 73

Wake Up Sunshine! (Stephanie Corfee), 89
watercolor paint
 Autograph Painting, 128–129
 Can't Resist Tie-Dye, 44–45
 cleanup, 18
 Daydream Painting: Working with Soft Pastel, 94–95
 Dimensional Outlines: Stained Glass Watercolor, 106–107
 If I Had Wings: Decorative Painting, 64–65
 Kaleidoscope Colors, 80–81
 Mystical Potion Painting, 52–53
 Ombré Ocean, 72–73
 Paper Towel Transfer Method: Moths 'Round the Moon, 112–113
 paper for, 16
 Photo Inspiration Color Study, 88–89
 Watercolor Blending, 22–23
 Watercolor Blob Characters, 48–49
 Watercolor Fireworks, 28–29
 Whole World in Your Hand: Painting in Miniature, 66–67
watercolor pencils
Draw-to-Paint: Water-Soluble Drawing Tools, 40–41
White Bright: Using White to Expand Your Palette, 86–87
water vessels, 14
websites
 Alex Leigh Franklin, 41
 Alicia Ferrara, 57
 Amy Adams, 37
 Anne Bollman, 23
 Asta Kundelyte, 75
 Barbara Chotiner, 35
 Bari J. Ackerman, 65
 Carolina Coto, 67

 Catherine Herold, 45
 Christine Mercier, 109
 Cynthia Shaffer, 113
 Elena Petrova, 133
 Flora Bowley, 119
 Heather Volkel, 73
 Jacqui Crocetta, 25
 Jane Wilcoxson, 29
 Jasmine Nixon, 63
 Jeanetta Gonzales, 129
 Jennifer Mercede, 131
 Jennifer Orkin Lewis, 125
 Jenny Doh, 105
 Jessica Swift, 27
 Jo Chambers, 55
 Katie Doucette, 101
 Kylee R. Wojtkiewicz, 127
 Lesley Grainger, 33
 Madeleine de Kemp, 117
 Maria Carluccio, 31
 Melissa Ramirez, 49
 Nancy Standlee, 51
 Pam Fish, 93
 Patti Robrahn, 77
 Peter H. Reynolds, 53
 Rebecca Jones, 87
 Toni Thomas, 111
 Tracey English, 97
 Traci Bautista, 39
 Valerie Wieners, 43
 Vanessa "Kiki" Johanning, 99
 Vassia Alaykova, 123
 Victoria Johnson, 95
 Wendy Brightbill, 85
 Zach Franzen, 103
 Zoë Ingram, 71
What a Drag: Scraped-Color Painting, 132–133
What Blooms in the Desert (Wendy Brightbill), 85
White Bright: Using White to Expand Your Palette, 86–87
Whole World in Your Hand: Painting in Miniature, 66–67
Wieners, Valerie, 43
Wilcoxson, Jane, 29
Winter Ombré Tree (Heather Volkel), 73
Wojtkiewicz, Kylee R., 127
Wood Plank Zebra: Staining Wood with Paint, 100–101

ALSO AVAILABLE
from Quarry Books

Collage Lab
978-1-59253-565-1

Print & Stamp Lab
978-1-59253-598-9

Drawing Lab for Mixed-Media Artists
978-1-59253-613-9

Jewelry Lab
978-1-59253-722-8

Art Lab for Kids
978-1-59253-765-5

Drawing Comics Lab
978-1-59253-812-6

3-D Art Lab for Kids
978-1-59253-815-7

Cupcake Decorating Lab
978-1-59253-831-7

Art Lab for Little Kids
978-1-59253-836-2

Creative Photography Lab
978-1-59253-832-4

We Rock! Music Lab
978-1-59253-921-5

Color Lab for Mixed-Media Artists
978-1-63159-064-1